CORNELIA PARKER

Cornelia Parker

The Institute of Contemporary Art, Boston

THIS CATALOGUE IS PUBLISHED BY
THE INSTITUTE OF CONTEMPORARY ART, BOSTON
ON THE OCCASION OF THE EXHIBITION

Cornelia Parker

FEBRUARY 2 TO APRIL 9, 2000

Copyright © 2000 ICA Boston
ISBN 0-910663-57-2
Library of Congress
CIP 99-080169
Distributed by
Distributed Art Publishers
575 Prospect Street, Lakewood, NJ 08701
1 800 338 2665

Catalogue design by Tamar Burchill, New York
Photography by Gautier Deblonde, Hugo Glendinning
Ansen Seale, Edward Woodward and
Courtesy Artpace, A Foundation for Contemporary Art, San Antonio
Printed in England by The Pale Green Press, London
This catalogue has been typeset in Bembo.

Front cover: **Mass (Colder Darker Matter)**, 1997
Charcoal retrieved from a church struck by lightning
With thanks to the Baptist Church of Lytle, Texas

Back cover: **The Negative of Words**, 1996
Residues left after engraving words into silver (by hand)

The Institute of Contemporary Art
955 Boylston Street, Boston, MA 02115

Contents

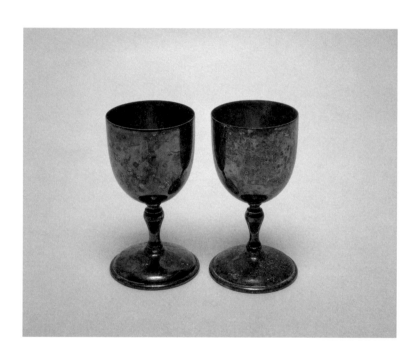

Twenty Years of Tarnish, (Wedding Presents), 1996
Two silver plated goblets

Foreword

JILL S. MEDVEDOW
James Sachs Plaut Director

The Institute of Contemporary Art is proud to present *Cornelia Parker*, the first solo presentation of Parker's work in a United States museum. Providing a survey of Parker's work from the last ten years, this exhibition concentrates on the artist's more recent installations, sculpture and works on paper. Parker's powerful and subtle work is both profoundly questioning and quietly witty, and we are delighted to have the opportunity to bring so many of her works together for the first time.

It is our aim to provide viewers with a much-deserved opportunity to delight in Cornelia's approach to the experiences and information of contemporary life. Her work presents a wealth of visceral and psychological associations to objects as eccentric and diverse as historical relics and kitsch souvenirs. Cornelia trades in the currency of daily life, often quite literally as in her pieces *Matter and What it Means*, and *Embryo Money*, which employ suspended and loose coins to grapple with both the particular and the abstract.

We are most grateful to Cornelia Parker, whose cooperation and passion have made possible this exhibition and the accompanying catalogue. It has been a pleasure to welcome her into the ICA family. Special thanks go to the lenders to this exhibition: Dimitris Daskalopoulos, Greece; Richard Lappin, New York; Eileen and Peter Norton, Santa Monica; Rebecca and Alexander Stewart, Seattle; Tate Gallery, London; and other private collectors who wish to remain anonymous. They have enabled the ICA to present many of Parker's most significant works to date.

Cornelia Parker would not have been possible without the generous support of our philanthropic partners. We are especially grateful to The Elizabeth Firestone Graham Foundation for providing major funding for this catalogue and we thankfully acknowledge the support of The British Council for their contribution towards the exhibition.

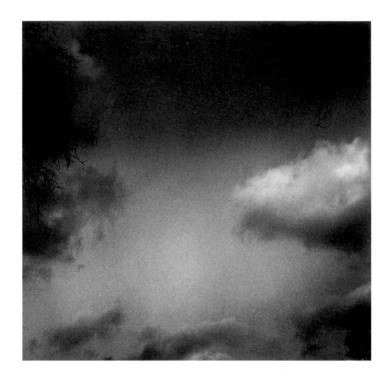

Avoided Object, 1999
Photograph of the sky above the Imperial War Museum taken with
the camera that belonged to Hoess, commandant of Auschwitz.

Acknowledgements

JESSICA MORGAN

This catalogue and the exhibition that occasioned it were made possible by the efforts of many people associated with the Institute of Contemporary Art. I am grateful to the museum's Director, Jill Medvedow, for her support and enthusiasm for this exhibition from its inception. I would also like to thank Nora Donnelly, Assistant Curator and Registrar, for her skill in organizing and managing all areas of the exhibition and catalogue, and Tim Obetz, Exhibitions Manager, for his excellent work installing the exhibition. Aaron Sherer, Naomi Arin and Tim Strawn have all worked hard on this project in their respective departments of Development, Grants and Communications.

For her creative input in designing this catalogue I would like to thank Tamar Burchill. Bruce Ferguson produced an insightful interview with the artist for this catalogue. Nico Israel has patiently helped me to hone my essay into its final form.

The following people also contributed significantly to both the exhibition and the catalogue: Jeff McMillan, Jane Hamlyn, Rose Lord, Johanna Winstrom, Dale McFarland, the London Fire Brigade, Jane Pierce, Trevor Stuart and Helen Statman.

Above all, I would like to thank Cornelia Parker, whose wit and wisdom have made possible every part of this exhibition and the accompanying catalogue. It has been a privilege and a pleasure to work with her.

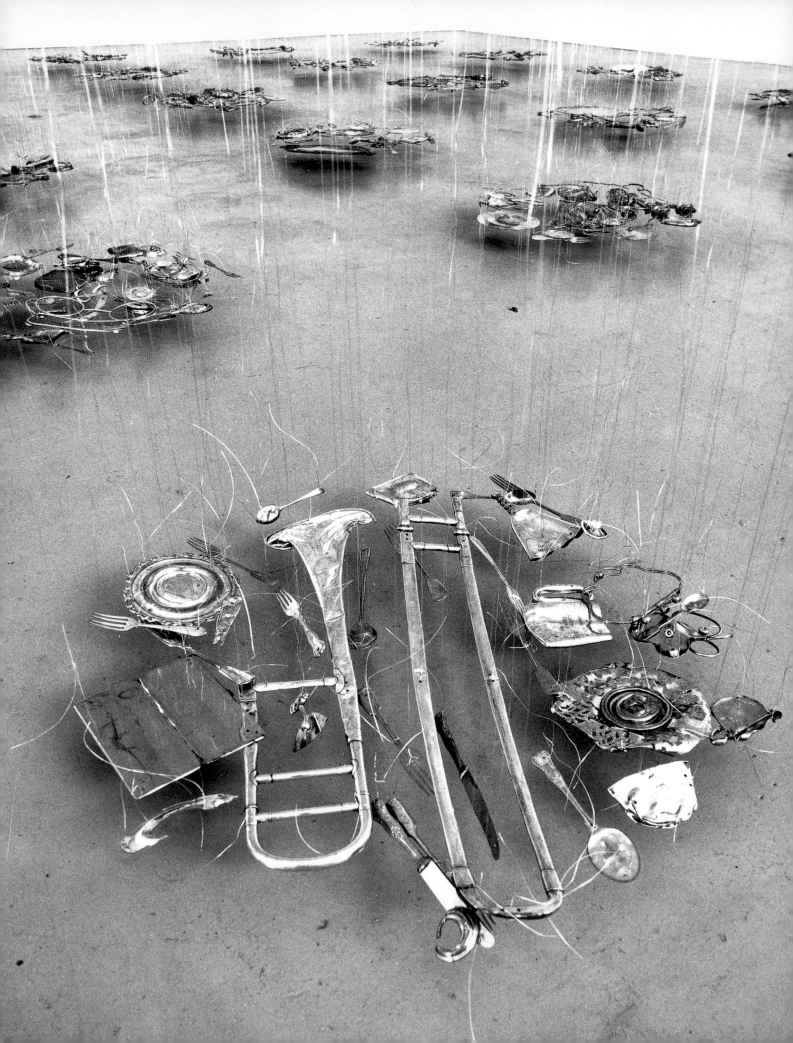

Matter and What it Means

JESSICA MORGAN

Matter and What it Means

The title of this work by Cornelia Parker from 1989 provides an apt description of the artist's searching, poignant, and witty approach to art making. Originally taken from a child's encyclopedia from the 1950s, a source Parker has cited as an early inspiration for her fascination with the less certain points of science, the title accompanied one of the simplified diagrams and entries for such apparently unfathomable phenomena as dark nebulae, the milky way and the hot red core of the earth. The blunt, dry title of the entry presents an unflappable, almost stereotypically English demeanor, one that insists that rational science will ultimately make sense of the great unknown. In the entries, the mysteries of time and space were frequently compared to everyday objects as if to make them more accessible—Everest's height measuring a hundred or so Big Bens, or the bottom of the ocean equaling a certain number of football pitches. This juxtaposition of the gigantic or the sublime with the comparatively minute and everyday (and even trivial) continues to inform Parker's work, and has enabled her to ask very serious questions with a deceptively light touch.

Parker has toyed frequently with this conflict between the macro- and the microscopic, the rational and the apparently irrational, revealing a powerful desire to put into bodily, human scale that which seems overwhelming. And yet, in contrast to the ever-ready answers of the children's encyclopedia, she eagerly complicates the "matter" at hand with an array of permutations, projections, and possibilities of what matter *might* mean. Through a combination of visual and verbal allusions, Parker's work triggers cultural metaphors and personal associations that allow the viewer to witness the transformation of the ordinary object into the abstract and extraordinary, and the monumental or unfathomable into the quotidian. Although Parker's methods are somewhat reminiscent of children's games and activities—collecting, discovering how things are made, or blowing them up—the manner in which she presents her final work is a sophisticated combination of object and concept. Parker mines the gap between matter and what it means, and the juxtaposition is akin to poetry or theatre.

Parker's work ought to be viewed in the context of, and ultimately distinguished from, British sculptors of the previous generation, the so-called New British Sculptors. The group, which included such artists as Tony Cragg, Bill Woodrow, Anish Kapoor, Richard Deacon, Michael Craig-Martin and Richard Wentworth, broke from both of the British traditions of the sublime and the monu-

Thirty Pieces of Silver,
1988-89
Steamrollered silver plate,
metal wire, p. 10

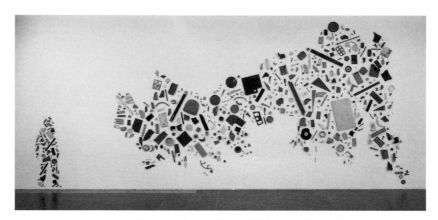

Tony Cragg *Britain seen from the North,* 1981, Courtesy Tate Gallery

mental in sculpture, exemplified in particular by Henry Moore, by developing a conceptual sensibility that frequently incorporated a lighter, more humorous touch. The combined use of everyday found objects and conceptual titles in the work of Cragg, Wentworth and Woodrow in particular had allowed these artists to investigate a broad range of references, both political and social, that until that point had been largely ignored by postwar British artists. The visual and the verbal established a mutually informing but often intentionally contradictory relationship in their work.

Cragg's series of mosaic-like sculptures made from plastic refuse and given deadpan titles bear the closest conceptual link to Parker's work. *Britain Seen from the North*, Cragg's sculpture from 1981, turns on its head the normative values and Southern-centric viewpoint of Britain. He presents an image of a map of Britain made out of found plastic remnants, in which the counties surrounding London, Britain's power base, are viewed from a northern perspective. Taken together (as taken apart), these scraps raise questions of value, authority and collective meaning, as well as political power—all prefiguring aspects of Parker's early work. Cragg's openness to associations and con-

text, and the diversity of his sources and content, set him somewhat apart from his New British Sculpture peers. He in particular serves as an integral link to Parker's work which has remained similarly open—wide open—to interpretation.

Equally and arguably more influential for Parker's use of conceptually charged but physically insubstantial materials were the artists associated with the Italian *arte povera* movement. Piero Manzoni's ironic gestures, for example his infamous cans of artist's feces (sold for their weight in gold), and *Socle du Monde*, an upside-down stone pedestal that suggests that it supports the globe, provided a generation of British artists with a humorous and conceptually savvy approach to art making. Particularly important for Parker is the succinctness of Manzoni's work—the capacity to make the most charged work with the least intervention. Within the simple gesture is a loaded complexity that appears all the more powerful for the lack of elaborate explication. The action, object and language are allowed to react in the viewer's mind and ferment. The artist's work, in a sense, is like an explosion with endless repercussions.

Indeed, Parker's early work was motivated by the desire to break apart the monumental. Both

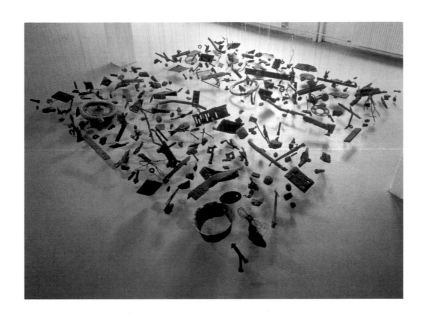

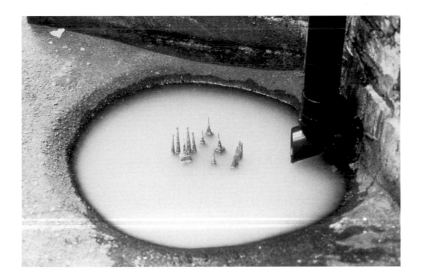

Avoided Object, 1995
Buried objects found in Dusseldorf, Germany with the aid of a metal detector.
Suspended above the ground to correspond to the depth discovered.

Drowned Monuments, 1985
Installation in a gutter of souvenirs of famous buildings

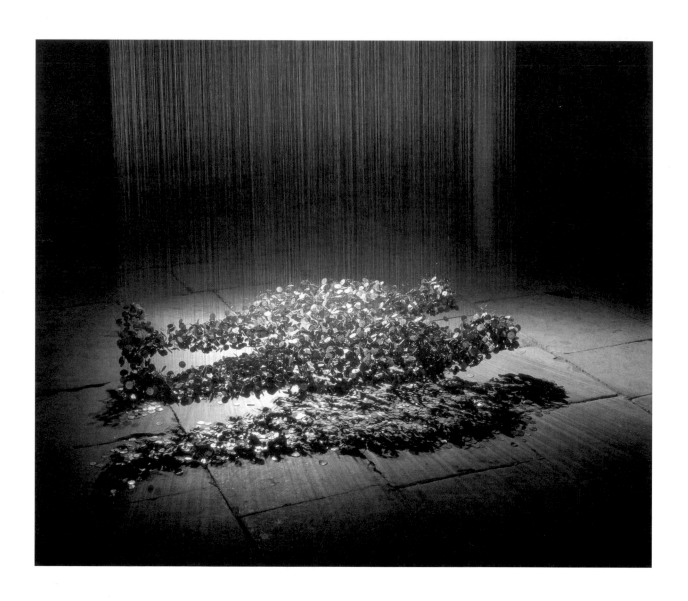

Matter and What it Means, 1989
Coins that have been run over by a train, suspended over a shadow of dirty money

objects (sculpture or monuments) and concepts (for instance religion or the institution of marriage) came under her wry wrecking ball. The question of *transformation*—from vast to minute, ethereal to worldly, spectacular to mundane—has continued to be a theme in her work that has developed more recently into a complex process comparable in idea to the religious notion of transubstantiation. Parker has suggested that her Catholic upbringing in the North of England informed much of her interest in the extraordinary effects of objects, language and belief when combined.

Both Cragg's and Manzoni's influence can be readily perceived in such early works as *Drowned Monuments.* For this temporary sculpture, Parker placed souvenir-Empire State buildings in a mock disaster scene flooded by a blocked drain. The tiny metallic structures in their mundane environment appear to be part of a child's imaginary re-creation of a disaster movie. Through the metaphorical breakdown of the monument or symbol of power, *Drowned Monuments* expresses an irreverence that is indebted both formally and conceptually to the work of these predecessors.

The comparison of Parker's work with that of Cragg begins to fade in the late 80s, when Parker rejected the studio-based practice that characterized Cragg's work and her own artistic practice gradually became more collaborative and experimental. While she still shared Cragg's fondness for ordinary or readymade objects, her use of found materials became increasingly conceptual. Beginning in the late 80s, Parker's focus on transformation resulted in a number of works that involved her acting upon various materials and causing a visible and conceptual change in their appearance and consequence. The role of the artist's agency in undertaking these transformations is often under-

played or even hidden in such a way that these and subsequent works also function as a critique of the artist-as-maker, a critique that connects Parker's work once again to Manzoni. However, while Manzoni's work is similarly concerned with questioning the auratic significance of the author and the original work of art, as is evidenced both in his canned feces and for the performative works for which he signed the arms of live models and declared them to be "original" Manzoni's, he does so through an exaggeration and overstatement of the act of agency.

Matter and What it Means and *Thirty Pieces of Silver,* Parker's two major works from 1989, incorporate materials upon which Parker performed an almost ritualistic but largely unexplained alteration; these in turn resulted in the type of layered, ricocheting associations that have become a signature of her work. *Matter and What it Means* consists of hanging coins in the shape of two insubstantial-looking human figures. Each of the coins that constitute the sculpture has been flattened, their suspended forms shimmering and twisting like particles of light. The accompanying artist written label says that the coins have been run over by a train and suspended over a shadow of dirty money; the audience is left to deduce how and when this transformation took place. The various elements of the work bring together a number of associations, from tradition of placing coins over the eyes of the dead (the horizontality of the figures suggesting a corpse-like repose); to suicides on train tracks; to the strangely domestic idea of "laundering" money. The flattened coins themselves, no longer of any conventional worth, have become an invented currency. The title suggests that the work will offer an explanation of something as complicated as the substance of the universe, and in fact the viewer is confronted with

a labyrinthine trail of clues and metaphorical markers that lead to no definitive conclusions. The pragmatic title is thus undermined by the insubstantiality of the work.

A similarly metaphorically rich series of events went into the making of *Thirty Pieces of Silver,* a work whose title prepares us for a story of betrayal of almost biblical proportions. First impressions of the installation reveal thirty silvery metallic pools suspended from the ceiling. Hovering at shin height, these pools reveal themselves on closer inspection to consist of mangled commemorative cups, crushed silverware, a twisted toast rack, a flattened trombone and other semiprecious silver plated objects, which the artist's label informs us have been crushed by a steamroller.

Parker had amassed a vast collection of abandoned silverware from garage sales and such, which she had placed in the middle of a quiet London road. The layout of the silver, as represented in the artist's photograph, resembles a careful procession somewhat reminiscent of, but utterly different in intent to, the photographs of Richard Long's interventions into the landscape; but it also brings to mind the sweep of red carpet traditionally rolled out for royalty or VIPs. The photograph shows the steamroller ploughing towards us, leaving something like a snail's silvery trail behind it.

Such silver plated objects represent a particular type of British etiquette in which the best teapot or cutlery is displayed to impress visitors. Parker's steamroller literally flattens class pretensions and transforms the rather pompous personal possessions into something both absurd and yet, as sculpture, still quite beautiful. Meanwhile, the silver—itself linguistically resonant not only with betrayal but with the metaphorical silver lining, quicksilver,

silver tongue, silver spoon, and silver screen (bringing to mind concepts as disparate as happy endings, fraudulence, eloquence, prosperity and celebrity) —is itself transformed into something else.

When asked about *Thirty Pieces of Silver* and her interest in transformation, Parker noted that, "Silver is commemorative, the objects are landmarks in people's lives. I wanted to change their meaning, their visibility, their worth, that is why I flattened them, consigning them all to the same fate...As a child I used to crush coins on a railway track. You couldn't spend your pocket money afterwards but you kept the metal slivers for their own sake, as an imaginary currency and as physical proof of the destructive powers of the world." Parker's work typically provokes such literal and metaphorical readings. Her combination of object and language and the often-violent fate that she imposes on her raw materials are all carefully chosen for their powers of destruction and reconstruction. Cognizant of our capacity for projection, Parker encourages the audience to question conventions, and by supplying fragments of an elaborate story (taking us from silver to sliver) asks us to make childlike leaps of faith—to fill in the blanks.

Like *Thirty Pieces of Silver, Left Luggage,* a temporary installation from 1989, similarly suggested the outline, or in this case the props and the stage set, for some kind of story. The installation, which took place on the platform of a central London train station, consisted of a collection of handkerchiefs and empty suitcases that had been attached by wire to a stationary train in such a way that the handkerchiefs were suspended mid air. The handkerchief, a cliché of filmic departure, added to the audience's expectation of the dramatic event that would ensue when the train tugged on the Lilliputian ties that tethered it to the platform. It

Thirty Pieces of Silver
work in progress
Hertfordshire
November, 1988
p. 17

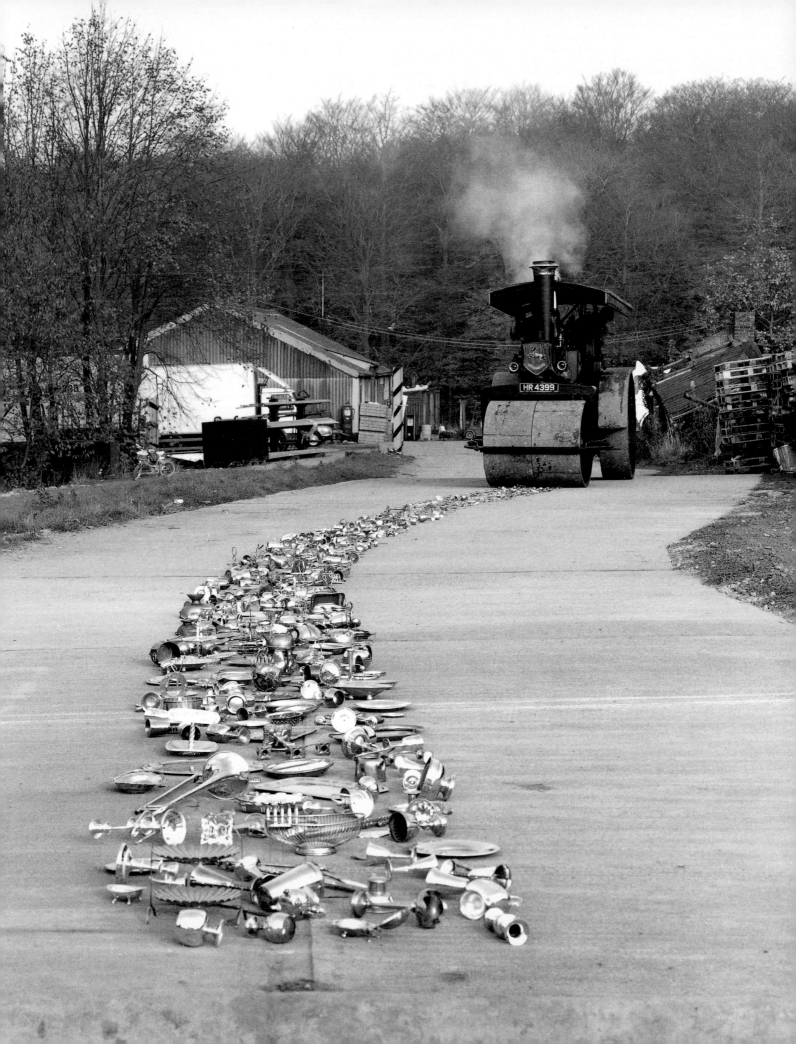

appeared that when the train pulled out of the platform, a flurry of waving handkerchiefs and dragging suitcases would bump along behind it like tin cans attached to the back of a newlyweds' car. However, when the train finally left the tethered objects merely collapsed on the platform in a deflated heap, and the event proved anti-climactic. Parker's aim was precisely to undermine the overblown drama and romance of the archetypal departure scene and to poke holes in the conventions of our collective storyboard.

Words that Define Gravity, 1992, p.20

In the documentary photograph of *Left Luggage*, the position of the handkerchiefs and suitcases in space is strangely reminiscent of both Duchamp's term for his ready mades, "object poems," and the proto-Surrealist poetry of Stephane Mallarmé. Mallarmé devised a radical layout of his poems in which the lines and stanzas are dispersed like elements in a picture. Parker's frequent use of suspension in her sculpture has a similar effect of liberating the elements within a work. Just as Mallarmé's words can be read visually as individual units or verses, Parker's sculpture both breaks apart into fragments and coalesces as an entirety, albeit an ephemeral-looking one. Suspension also implies surprise or tension, qualities that are vividly present in Parker's work, which constantly appears to be in transition, either falling down or propelled up, or caught miraculously midway in limbo. Suspension in Parker's sculpture however, is as much about displacement as it is about a suspension of disbelief, and both result in the desired transformation of the familiar or prosaic into the unfamiliar realm of poetry.

The analogy to poetry and writing is reinforced by Parker's choice of titles such as *Neither from Nor Towards* and *Gravity was the Trigger* which are both taken from literature (respectively T.S. Eliot's *Burnt Norton* and Minor White's *Found*

Photographs) or the made up poetry of found or invented titles such as *Matter and What it Means* or *Avoided Object*. Like the Surrealists, Parker, carefully negotiating between profundity and cliché, is drawn to language's edges and elisions. One of her most resonant works from this period, *Words that Define Gravity*, takes flight from a dictionary definition of gravity. Dictionaries, though intended to fix the meaning of words, can have the effect of opening up a labyrinth of possible, historical and related words and meanings such that a search for the most innocent definition can be complicated and utterly changed.

For *Words that Define Gravity*, Parker cast in lead word by word the dictionary entry for gravity. Then, in a performative act of literal translation, Parker threw the leaden words off the White Cliffs of Dover, as if to test their true weight or worth. In British folklore and poetry (that of Matthew Arnold, for example) the cliffs, the outermost point of England, are known as the place where certainty ends and uncertainty begins. Parker's gesture, while literally testing the effects of gravity and the rate (and fate) of the objects' fall, ultimately thrust the definition into another realm of language or interpretation. The broken definition dropped through the air as separate elements— like Mallarmé's poetry only this time in three dimensions—and landed crushed and transformed at the bottom of the cliffs. Parker's action was simultaneously one of suspension, displacement, destruction and transformation.

A photograph of Parker in action, gazing towards the horizon as the word "specific" lingers mid-flight, is reminiscent of Yves Klein's dramatic leap into a void, and once again links Parker's work to a French proto-conceptual tradition. Indeed it is with these early beginnings of conceptual art that Parker's work appears to have a closer affinity

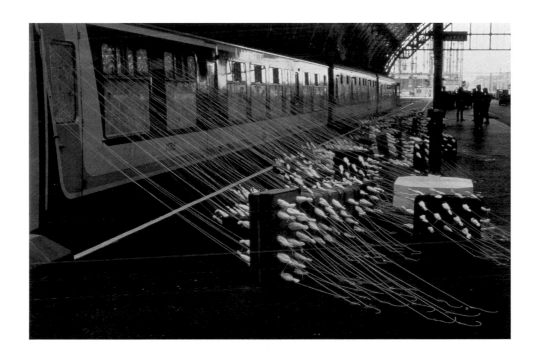

Left Luggage, 1989
Installation at St. Pancras St. London
Suitcases full of holes, handkerchiefs and string, sculpture
destroyed by the train pulling out of the station.

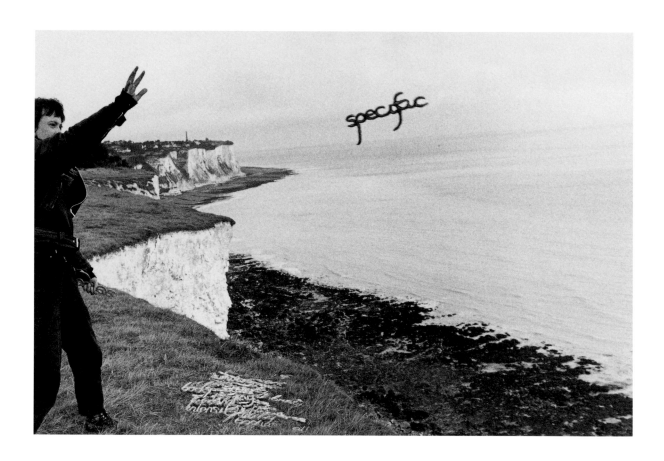

Words that Define Gravity, 1992

A definition of gravity, made in lead then thrown off the
White Cliffs of Dover

rather than with the 70s conceptual art movement. Despite her use of such titles as that of her 1996 exhibition *Avoided Object*, that suggest a desire to abandon the object completely in her art (a desire that she has at times expressed), Parker's work typically takes a different tack. Parker searches for the negatives, opposites, or contradictions in objects in order to upset the viewers' normative reading and to open up alternative interpretations. The physical material remains paramount to the work, often functioning as a not so innocent springboard for the metaphorical or conceptual content. Parker's patent humor further distances her from a more dour American conceptual art tradition and brings her work closer to the sophisticated game playing of artists associated with both surrealism and *arte povera*. Like her British peers Rachel Whiteread and Mona Hatoum, moreover, her work has a formal and physical presence at odds with a classic definition of conceptual art.

The play between the binaristic metaphors of cohesion and explosion, stasis and transformation, suspension and gravity structure meaning in Parker's project, providing it with a thematic consistency despite her use of a multitude of materials and methods. One could add to this catalog of metaphors the notion of inhaling and exhaling. The idea of releasing air—both as a sense of relief and a discarding of pretension or formality—is woven into much of Parker's work. It is evident both in *Thirty Pieces of Silver* as a forced removal of the hot air of snooty tradition, and in the temporary public project, *Exhaled Schoolhouse*, that appeared to be the work of a liberated schoolteacher driven over the edge. For this project, Parker covered a Victorian red brick schoolhouse with tiny chalk marks, suggesting that the laborious action involved was reminiscent of the process of marking time in a relatively unchanging, institu-

tionalized place. Parker has described how she imagined that the years of accumulated chalk marks inside the school had been swept out in a giant sigh. Viewed from a distance, the schoolhouse appears to have been caught in an isolated snowstorm of chalk lines. Like other works by Parker, *Exhaled Schoolhouse* explored the possibilities of exposing a hidden interior, revealing the guts or internal workings of an institution or edifice.

Parker fashioned one of her most elaborate installations in 1991, *Cold Dark Matter: An Exploded View*. Visitors entering the Chisenhale Gallery in London first encountered a photograph of an ordinary garden shed. This shed had apparently been uprooted from its original location and placed in the Chisenhale Gallery where it had been photographed. Turning the corner, entering the space where the shed had been photographed, visitors were now confronted with fragments of the same shed, which had clearly undergone a massive explosion.

Parker's choice of the humble garden shed for this project draws upon a British popular notion of the shed as both a site of reclusive, secretive, anti-social or escapist activities, and as a predominantly masculine domain akin to the American garage. Like Christo's storefronts, the shed had the appearance of a familiar but outmoded object that, once placed in the rarefied atmosphere of the museum or gallery, could now be appreciated for its uncommon and previously overlooked beauty. Inside the shed, as the photograph revealed, had been a collection of garden tools, lumber, domestic appliances and odds and ends of the type that generally end up hidden and unused. As she had for *Thirty Pieces of Silver*, Parker gathered this assortment of material from rummage sales, so that the objects carried the history of their use,

Exhaled Schoolhouse, 1990
Schoolhouse in Glasgow, exterior entirely covered in chalk marks p. 55

Cold Dark Matter: An Exploded View, 1991
Garden shed, blown up for the artist by the British Army, the fragments suspended around the lightbulb from the shed, p. 25

eventual disuse, and ultimately rejection. Visitors to the gallery were asked to piece together possible connections between the contents of the shed, which included a copy of Proust's *Remembrance of Things Past*, and the shed itself.

For the second phase of *Cold Dark Matter: An Exploded View*, Parker collaborated with the British armed forces. She transferred the shed to the base for the army's School of Ammunition and, with the unlikely permission of the fighting force, had a controlled explosion performed. The destroyed pieces, now mangled, burnt and utterly transformed, were carefully gathered together and brought back to the gallery, where Parker suspended the fragments on thin wires around the single bare light bulb that had once hung inside the original structure. The suspended particles appeared like a constellation of planets and stars. It was as though she were recreating in three dimensions the type of diagrams she had admired in children's encyclopedias, fashioning a bizarre solar system of metal scraps and twisted objects. After the bang of the explosion—a Big Bang of sorts--these household objects became a universe unto themselves. In performing this explosive intervention, Parker dealt a humorous blow to a British convention: the shed, a British institution, was blown up by another British institution, the Army.

After this experience of collaborating with the army, Parker worked with groups as otherwise unlikely to be seen in the art world as the British Customs and Excise department, the Royal Mint, NASA, a Connecticut arms factory, the daughters of the Republic of Texas, and a group of lighthouse attendants. Many of these unlikely collaborations have resulted in smaller works by the artist that, in comparison to her large scale installations, are like tightly constructed poems in which

every word has been chosen for the optimum effect. Parker's *Embryo Firearms* and *Embryo Money* (made respectively with the participation of Colt Firearms factory in Connecticut and the Royal Mint) investigate the powers of transformation. For these works Parker displayed the objects in their earliest stages of production, the ten pence pieces are blank metal discs and the guns are a simple, recognizable shape with just the beginnings of a barrel and trigger. At what point, Parker asks, is the power of money and guns imprinted, instilled or conveyed in these otherwise innocent lumps of metal? Parker's work is concerned with this moment of transubstantiation as well as with the viewer's and consumer's role in bringing about this change from meaningless object to powerful metaphor. The use of the word "embryo" in each of the two titles adds another layer of meaning to Parker's investigation of use and exchange value: invoking the vociferous debate concerning abortion, she casts doubt upon when the "life" of an object begins. How, she seems to ask, can these innocent lumps of metal later take on such a powerful presence?

Parker's relationship with the British Customs and Excise department developed in part after she was stopped leaving America with the *Embryo Firearms* in her luggage. An argument ensued that perfectly reflected the questions raised by Parker's work. The American Customs department insisted that *Embryo Guns* were weapons, while the police department, in Parker's defense, argued that they were harmless metals forms and Parker was released from questioning. Intrigued by the idea that British Customs and Excise was also in the business of destroying confiscated contraband, Parker persuaded the authorities to give her some of the cut up pornographic tapes that were among the items they had destroyed. Parker's *Pornographic*

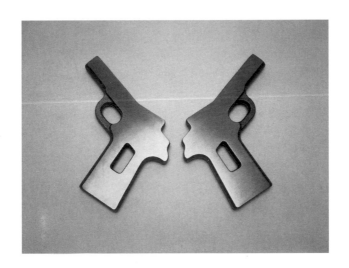

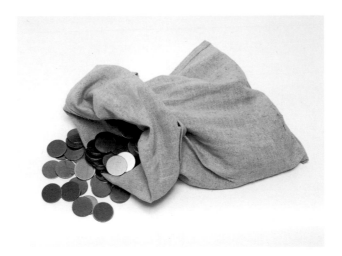

Embryo Firearms, 1995
Colt. 45 guns in the earliest stage of production

Embryo Money, 1996
Ten pence pieces in the earliest stage of prodution

Cold Dark Matter: An Exploded View, 1991
Garden shed, blown up for the artist by the
British Army, the fragments suspended around the
lightbulb from the shed.

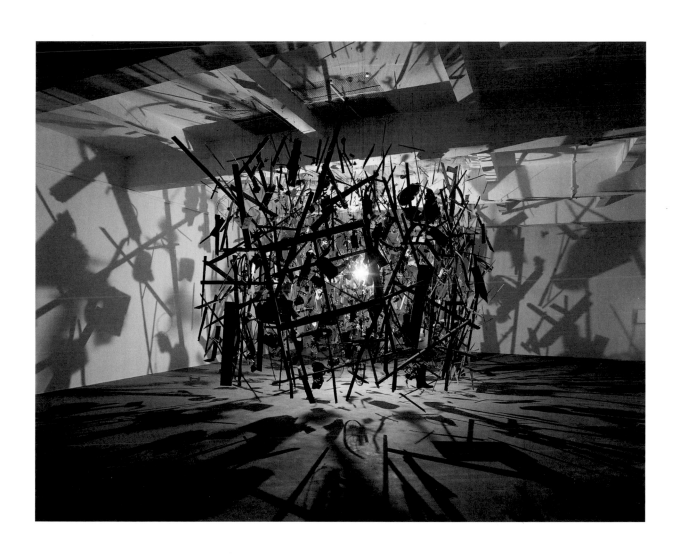

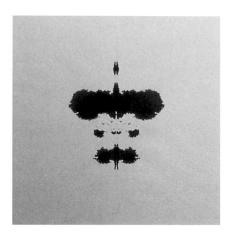

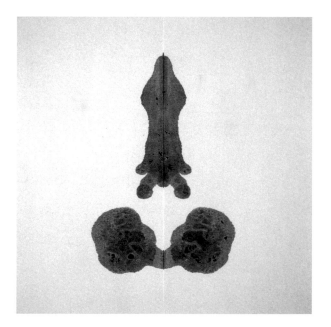

Poison and Antidote Drawings, 1997
Rattlesnake venom and ink, anti venom and correction fluid

Pornographic Drawings, 1997
Ink made from dissolving pornographic videotape (confiscated
by HM Customs & Excise) in solvent

Drawings were made by adding solvents to the tape and then creating Rorschach blots from the solution. Parker simultaneously managed to raise questions about sexual censorship, individual taste and psychoanalytic technique with a quiet understated eloquence.

Unsurprisingly, Freud plays a large role in a series of works that Parker made in collaboration with the Freud Museum in London's Hampstead. One of the most compelling works from this series —titled, appropriately, *Projection*—consists of a feather from a pillow from Freud's analysands' couch presented in a glass slide that is projected onto the wall and lit in such a way that it creates a three-dimensional-seeming anamorphic image. The projected tiny feather takes on vast proportions and becomes akin to a projectile hurtling through the gallery space suggesting a physical translation of the act of psychological projection. The feather brings to mind both Freud's extensive contributions to dream analysis and the site where the machinations of the unconscious were originally revealed. While thus again invoking minimalist literality and truth to form, Parker's title is somewhat ambiguous, suggesting a healthy dose of skepticism in regard to Freud's theories but also drawing the viewer's attention to the role of projection in viewing any work of art.

Other small-scale works by Parker have developed out of her interest in the potential of specific materials. The rich associations of silver brought into play for *Thirty Pieces of Silver* are also evident in a series of smaller works in this medium. The *Negative of Words* appears to be a small pile of curly silver threads. An accompanying label explains that the material is silver residue accumulated from the laborious process of engraving words by hand. "Engraved words are always monumental in some way," Parker has said, "They're never swear words. So what would their inverse be?" Perhaps this work perfectly sums up Parker's notion of an avoided object: it is not the recognizable, familiar object that is presented but something other and unfamiliar. Another work that functions in a similarly "avoided" manner is *Collected Death of Images* (the lost particles) for which Parker presented the silver particles left over from the process of "fixing" an image with photographic chemicals. These remnants of silver are collected and fashioned into very thin sheets of silver. Parker's work suggests that these slivers of silver contain lost images—the ghosts that slipped away and are now inhaled within and trapped by the material. Like the found silver used for *Thirty Pieces of Silver*, Parker draws attention to the hidden history or meanings contained in objects that can only be alluded to or imagined in the same way that the unimaginable depths of cold dark matter remain elusive. It is this uncharted terrain that for Parker contains the richest metaphorical and experiential associations.

Parker's fascination with the compelling comparison between miniature and gigantic appears again in a series of measured works that involve drawn silver and gold. *Measuring Niagara with a Teaspoon* is precisely that: a Georgian silver teaspoon melted down and drawn out to the height of the Falls. By comparing the sublime Falls with a domestic object and containing references to both within a drawing, Parker thus brings the natural and cultural together. Parker's work *Wedding Ring Drawing (circumference of a living room)* is somewhat more ambiguous and represents an attempt to quantify or measure the boundaries or limits of domesticity using the metaphorical space of the living room. The drawing itself is a curly mass of twisting gold thread suggesting that the paths and turns of a relationship are anything but the simple

The Negative of Words, 1996
Residue left after engraving words into silver, *back cover*

Measuring Niagara with a Teaspoon, 1997
Georgian silver spoon drawn to the height of Niagara Falls, p. 27

Wedding Ring Drawing, 1996
(Circumference of a living room)
Two 22 carat gold wedding rings drawn into a wire, p. 44

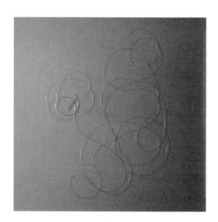 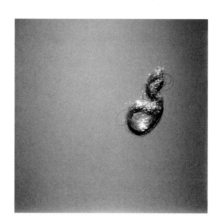 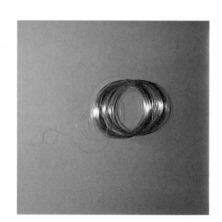

Three Fathoms in a Thimble, 1997
Silver thimble drawn into wire and threaded through a needle

Measuring Niagara with a Teaspoon, 1997
Georgian silver spoon drawn to the height of Niagara Falls

Measuring Liberty with a Dollar, 1998
Silver dollar drawn into a wire the height of the Statue of Liberty

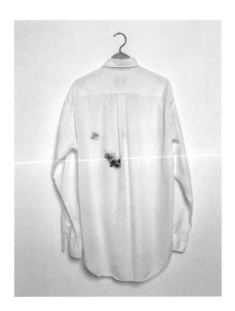

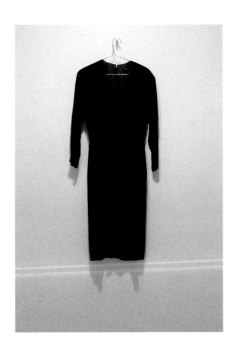

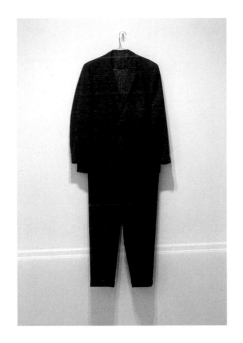

Shirt Burnt by a Meteorite, 1996

**Dress, Shot with Small Change
(Contents of a Pocket)**, 1995

Suit, Shot by a Pearl Necklace, 1995

cube of a domestic space.

While these smaller works have the effect, through subtlety or outrageous comparison, of forcing the viewer to question certain values, a series of works Parker made in the mid 90s concentrate on the question of agency or lack thereof. *Dress Shot by Small Change* and *Suit Shot by Pearl Necklace* suggest a bizarre lover's quarrel where the closest object at hand was used in a crime of passion. The clothing is presented as though it were evidence for trial, or, perhaps, as objects in a museum devoted to unlikely mysteries. What is significant in both cases is that the agent doing the shooting is absent or questionable: we have only the verb's past participle as a clue. Similarly, playing with the idea of unusual projectiles and unknown causes and returning to the theme of juxtaposing the micro and the macro, *Aircraft Carrier Shot by a Dime* suggests an event worthy of David's battle against Goliath. In fact the object presented is one of Parker's favored encyclopaedias that she has had shot through by a dime that happened to tear into the picture of U.S. aircraft carriers. The random connection recalls John Cage's experiments with maps and sound that similarly brought together unrelated things allowing the audience to develop the connections. Perhaps most perplexing of all Parker's works are those involving a meteorite. For *Shirt Burnt by a Meteorite* Parker plays on the popular imagination's attraction to unlikely natural occurrences, such as being hit by lightning or caught in a whirlwind. The singed white shirt, like the shot clothing, is presented as a curiosity in Parker's personal museum.

Indeed, these smaller works often give the impression of belonging to a collection of strange ephemera gathered together for a purpose that remains elusive. Parker's favored presentation is that

Aircraft Carrier Shot by a Dime, 1995
Dictionary shot by a coin, p. 49

of a fictional museum: the objects are laid out in vitrines; and the accompanying labels and descriptions mimic museum labels—not so much those of an art museum but of an ethnographic, historic or scientific museum. While many of Parker's works masquerade as faux-museum presentations one project in particular developed a more complex and elaborate analysis of the relationship between the viewer and the objects on display.

The Maybe, a collaboration between Parker and the British actress Tilda Swinton (who starred in, among other things, the film version of Virginia Woolf's *Orlando*), took place at London's Serpentine Gallery in 1995. Swinton, set somewhat apart in a large room, lay asleep in a glass case during the day for seven days. The rest of the exhibition, presented in the surrounding galleries, consisted of various objects associated with famous, infamous, historical and unusual people (all of whom were dead) selected by Parker and Swinton, placed in vitrines and accompanied by descriptive labels. The objects displayed were often physically unimpressive but metaphorically weighty, inspiring or humorous. They ranged from Queen Victoria's stocking to Charles Dickens' quill (the one he used to write his last novel *The Mystery of Edwin Drood)* to the painter Turner's box of watercolors to the ice skates of abdicated King Edward's American mistress Wallis Simpson. Also shown was a four inch long fragment of the aircraft in which Lindbergh crossed the Atlantic in 1927; the preserved brain of Charles Babbage, inventor of the earliest computer; the pillow and blanket from Freud's couch; and the spurs from itinerant methodist preacher John Wesley. Like relics or the attributes of saints, the objects were presented as stand-ins for the absent subjects and pointed to their achievements, peculiarities or character. Parker curated the exhibition in such a way that

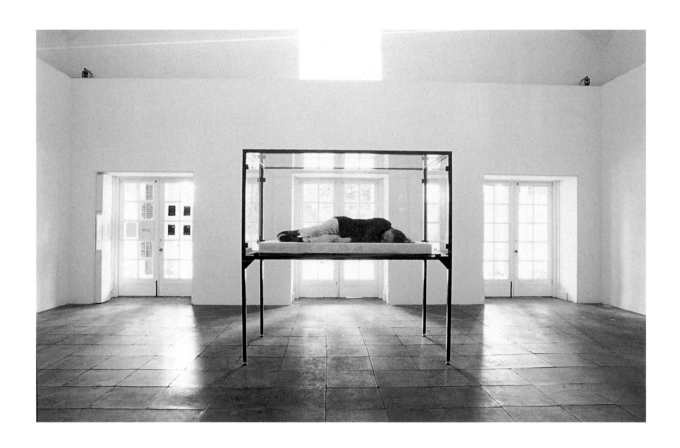

The Maybe, 1995
Matilda Swinton (1960-)
Installation at the Serpentine Gallery, London,
a collaboration between Cornelia Parker and Tilda Swinton

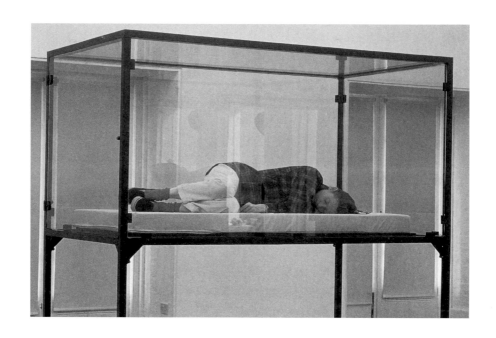

The Maybe, 1995
Matilda Swinton (1960-)
Drawing done by a cat
Blanket and pillow from Freud's couch
Scrap of Lindbergh's plane
The brain of Charles Babbage
Queen Victoria's stocking
Charles Dickens' quill with which he wrote
The Mystery of Edwin Drood
Mrs. Simpson's Ice Skates

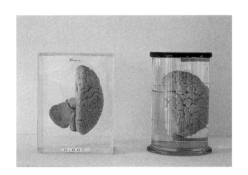

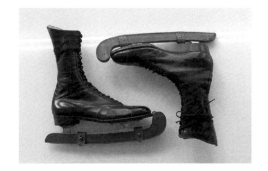

unexpected associations developed—both historically monumental and downright silly. By connecting Queen Victoria's stocking with Wesley's spurs, for example, you could imagine the darned hole in the stocking as having been made by a spur: is there, then, a hole in the royal armature? Is the famously icy Victoria actually a seductress of sorts? *The Maybe* encouraged such imaginary narratives but also functioned as a reflection on the general public's reverence for the famous and infamous and our capacity to devour any information or object associated with celebrity. This veneration perhaps contradicts what we now assume to be a celebrity saturated culture. Yet, as the writer Adam Gopnik has noted, "Everyone nods when someone says again that everyone is now famous for fifteen minutes, but the truth is that almost none of us are famous at all, not even for five…To be very rich or very lovely or very sure or very bad is inherently interesting, since veryness of any kind is not part of dailyness."

The inclusion of the "very" living yet sleeping Swinton complicated the presence of the objects and acted both as the only example of a living semi-famous person but also as a reminder of the mortality of the previous owners and users of these objects. Swinton's sleeping, exhibitionistic figure drew a parallel with Sleeping Beauty, precursor for the modern celebrity relic, kissed to life by us as consuming Prince Charmings. Visitors to the gallery were made constantly aware of and nervous by the strange person hovering between presence and absence, history and everydayness. Swinton's celebrated figure provided the transformative energy or pulse for these dead objects to come alive; yet their odd durability reflected, vanitas style, on her (and our) mortality.

In his oft-quoted essay "Valéry Proust Museum," Theodor Adorno notes that "The German word *museal* (museumlike) has unpleasant overtones. It describes objects to which the observer no longer has a vital relationship and which are in the process of dying. They owe this preservation more to historical respect than to the needs of the present. Museum and mausoleum are connected by more than phonetic association. Museums are the sepulchers of works of art." Parker's *The Maybe* clearly acknowledges the mausoleum-like overtones of the art museum, indeed almost to the exclusion of any actual, recognizable objects of art. On one level, then, her work could be read as an endorsement of the critique of the museum as a crypt-like container for the relics of the dead. However, the art in *The Maybe* also invokes the phoenix-like creation of an entirely new fiction from these deathly remains. Parker clearly views these objects as ripe for projection and interpretation and rescues them from languishing uncreatively in the sterile environments of their more conventional museum surroundings.

Numerous artists have "curated" exhibitions over the past three decades, from Marcel Broodthaer's fictional museums and his later exhibition centered on the symbolic and historical role of the eagle that was presented at the Düsseldorf Kunsthalle, to Claes Oldenburg's *Mouse Museum* or the museums created in the 1960s by Richard Hamilton or Andy Warhol. But perhaps the most significant predecessor for *The Maybe* would be Daniel Spoerri's *musée sentimental*, one of the first examples of which took place at the Centre Georges Pompidou in 1977. One part of this exhibit consisted of objects belonging to artists or famous French figures—Magritte's bowler hat, Rimbaud's suitcase or van Gogh's furniture from his home in Auvers-sur-Oise—objects that referred to the occupation, biography

or character of the owner. Later musées sentimentales included an elaborate attempt to describe the destroyed city of Cologne in a project at the Ludwig Museum. Spoerri included such disparate objects as a piece of lead that had hung from the city cathedral's tower since it was bombed during the war. The piece of lead was taken down and displayed with a label explaining its provenance. Also included was the leather jacket of the first drug addict killed by an overdose in Cologne and paraphernalia associated with various overlooked or ephemeral historical or contemporary sites and people.

Spoerri modeled these collections on the idea of the renaissance cabinet of curiosities—now frequently heralded as the precursor to the modern museum. Like Parker's work, Spoerri throws together history, memory, science and myth, leveling each to the same importance or equal roles in a bricolage. Spoerri's projects in Paris and Cologne are both concerned with establishing the nebulous idea of a community memory—a national or urban history that aspires to include a diverse range of images beyond the realm of traditional historical documents. In fact Spoerri's project with the musée sentimental appears to be quite specifically an attempt to rewrite history or the process of writing history by making it more inclusive: an accounting of what Walter Benjamin calls the Namenlos—those passed over in official history.

Although *The Maybe* shared this eccentricity of choice and some of its ambitions, it was less of an attack on traditional museum presentation than a subversion of any strictly linear historical approach to the reception and display of objects and ideas. As with her individual works, Parker's concern was to create a collective alchemy such that the combination of objects, forms and language takes on a life or narrative of its own to be developed by the audience. Within the works on display, the artists raise the interrelated issues of memory, death and fetishism that traditional museums rely upon, but allow the audience to make visual and historical connections as well as imaginary or invented narratives.

Guy Debord, theorist of the spectacle, noted how an excess of display has the effect of concealing the truth of the society that produces it, providing the viewer with an unending stream of images that might be best understood, not simply as detached from a world of things, but as working to efface any trace of the symbolic and allowing us, as viewer-victims, only a random choice of ephemera. *The Maybe* attempts to arrest this relentless flow of images or at least to divert the viewer's attention to the overlooked and under-examined and to encourage an active role in establishing connections and inventing narratives. And does so in a playful way that feminizes Debord's dystopian totalizations.

A series of works made after *The Maybe* attest to Parker's continued interest in the history of the museum and the role of the museumification of contemporary culture. For *Shared Fate*, Parker cut various objects, such as a loaf of bread, a necktie and some playing cards, with the guillotine used to behead Marie Antoinette. This guillotine is in the collection of Madame Tussaud's, the waxwork museum in London that contains the largest collection of contemporary wax figures—living relics. In his essay, titled "Museum," Georges Bataille writes that "According to the Great Encyclopaedia, the first museum in the modern sense of the word (meaning the first public collection) was founded in France by the Convention of July 27, 1793. The origin of the modern museum is thus linked to the development of the guillotine." As if

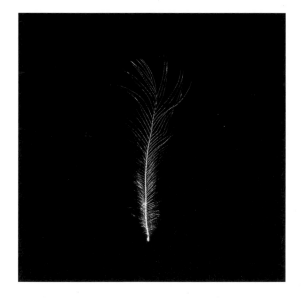

Tarnish from James Bowie's Soup Spoon, 1997
(Inventor of the Bowie knife)

Feather that went to the South Pole, 1998
(In the sleeping bag of Sir Ranulph Fiennes
on his trip across Antarctica)

to complicate matters further, one of the earliest waxworks in Tussaud's collection, presented in a nearby gallery, is in fact an eighteenth century representation of Sleeping Beauty, who is shown complete with a pumping, simulated-breathing breast for full effect.

Parker thus manages to weave together in a dense, tragicomic tapestry, a series of historical and metaphorical narratives, from the bread that might have replaced Marie Antoinette's "let them eat cake" to the figure of the inspired sleeping beauty. Together, these narratives suggest a number of possible origins for the museum while simultaneously connecting this historical trajectory to the contemporary life of the objects cut by the guillotine, and, implicitly, to the wounds of contemporary politics.

Similarly testing the viewer's belief in the power of association, Parker created a number of works titled *Tarnish Drawings*. Among these tarnishes are those from King Henry VIII's armor, and silverware from the collection of James Bowie, inventor of the Bowie knife. The act of rubbing that produced the tarnish suggests the children's story of the genie in the magic lantern. It is as if Parker attempted to make appear the spirit of the object's owner by polishing the surface. The resultant drawings appear like ghostly grey shadows. Closely related to these drawings are a series of photographs by Parker of the chalkboards on which Einstein's formulas still exist. Parker framed close-ups of the chalk markings that appear alternately like streaking stars on a night sky, or the loose, expressionist markings of Cy Twombly, or even perhaps a handwriting specialist's attempts to divulge genius or insanity.

For one of her most recent and most dazzling works, Parker produced a dramatic sequel to *Cold Dark Matter*. During a residency at ArtPace in San Antonio, Texas, Parker heard of a church that had burnt to the ground, having been struck by lightning. Parker was given permission to gather the charred remains from which she made *Mass: Colder Darker Matter*. For this extraordinary installation, a charcoal drawing in space, Parker suspended the fragments in a simulation of an explosion, dense at the center and gradually falling off at the edges. The overall impression brought to mind once again her recurrent theme of exhalation and explosion. Like its predecessor, *Cold Dark Matter*, it appeared to capture a dramatic movement and suspend time in the space of the gallery—in much the same way that Swinton's sleeping figure in *The Maybe* appeared to suspend the moment between life and death. The bizarre natural occurrence—a place of God that was destroyed by an "act of God"—inevitably led to speculation as to the cause of such an event. The concurrence of a natural disaster in such an explicitly religious environment aptly matched Parker's interest in the meeting of such apparent opposites as faith and science. The charcoal itself took on the importance and value of a relic, as if the building, having undergone this process of transubstantiation, had now become a nigh-religious object or the subject of a miracle.

Parker's next large-scale work, *The Edge of England*, presented a visual and conceptual antidote to the charcoal installation. Here, Parker suspended a thick curtain of lumps of white chalk from the White Cliffs of Dover. This man-made landscape brought to mind the fragility of this stretch of land that is gradually suffering from erosion and thus quite literally shrinking the country. Again Parker called on the folkloric importance of this site at the edge of an island that resolutely remains separate from Europe, and in this respect the work is very much about the

Mass (Colder Darker Matter), 1997
Charcoal retrieved from a church struck by lightning
With thanks to the Baptist Church of Lytle, Texas
front cover

Edge of England, 1999
Chalk retrieved from a cliff fall, Beachy Head, South coast of England, p. 38

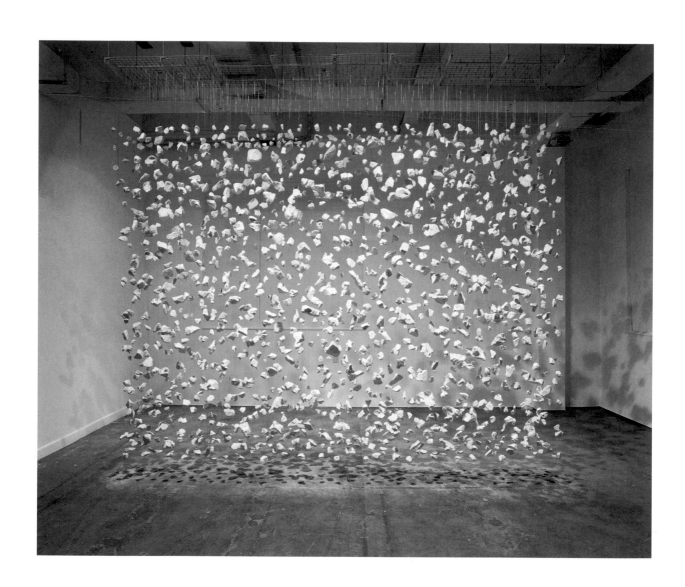

Edge of England, 1999
Chalk retrieved from a cliff fall, Beachy Head, South coast of England

traditions and conventions of an isolated country. From a purely formal point of view the work is considerably flatter than the other suspended works and is viewed more like a painting—or rather, akin to Manzoni's achromes, like a collage.

Parker's next major suspended project implied more sinister origins than the natural occurrences that contributed to the making of *Mass: Colder Darker Matter* and *The Edge of England*. Re-invoking the question of agency in her work, Parker made *Hanging Fire (suspected arson)* a suspended charcoal work made from the burnt remnants from a case of suspected arson. Parker installed the work in the eighteenth century rooms of the Frith Street gallery in London. The blackened wood remains were suspended in front of the fireplace in such a way that the dimensions of the work reflected those of the fireplace and chimney. *Hanging Fire* thus appeared to have leapt magically from the hearth into the center of the room. Whereas *Mass: Colder Darker Matter* had presented the burnt remains as vertical black lines, Parker positioned the suspended fragments of *Hanging Fire* to replicate the criss cross pattern of wood on an open fire or the collapsed remnants of a burning building. The relatively orderly appearance of *Mass: Colder Darker Matter* suggested a glorious ascension or a brightly radiating sun,

while in violent contrast the crashing timbers of *Hanging Fire* conveyed the criminal, potentially homicidal intentions of the culprit.

These last three major works by Parker constitute a substantial change in her approach to developing narrative in her work. While T*hirty Pieces of Silver* or *Matter and What it Means* required Parker's agency in the series of events that resulted in the transformation of the materials, for *Mass: Colder Darker Matter, The Edge of England* and *Hanging Fire* the primary agent in the act of transformation is something or someone other than Parker. It is as though Parker discovered that it was not necessary to fabricate the layered histories or associations that typically structure her work. In fact, such complex and provocative stories or events can be found in the artist's surroundings. Parker's task, then, is to frame, edit and retranslate these phenomena in such a way that the extraordinary in science and daily life can be perceived as meaningful in a philosophical, conceptual and even spiritual way.

Parker's investigation of matter and what it means has thus returned to the territory of the children's encyclopedia but now it is Parker who confronts us with the mysteries of time and space, and, in so doing, returns us to a childlike state of wonder.

Hanging Fire (Suspected Arson), 1999, p. 65

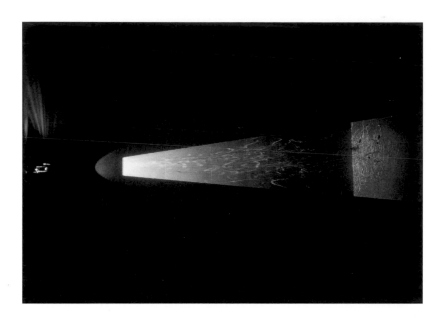

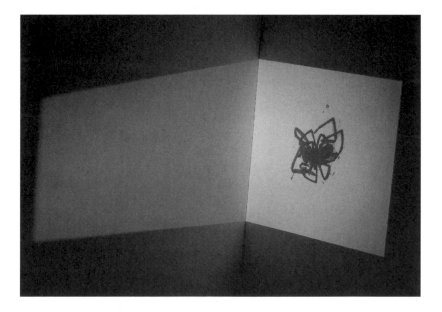

Exhaled Blanket, 1996
Dust and fibres from Freud's couch, trapped in a glass slide then projected
Exhaled Blanket, (detail) 1996, p. 41

Spider that Died in Mark Twain's House, 1997
Spider in glass slide

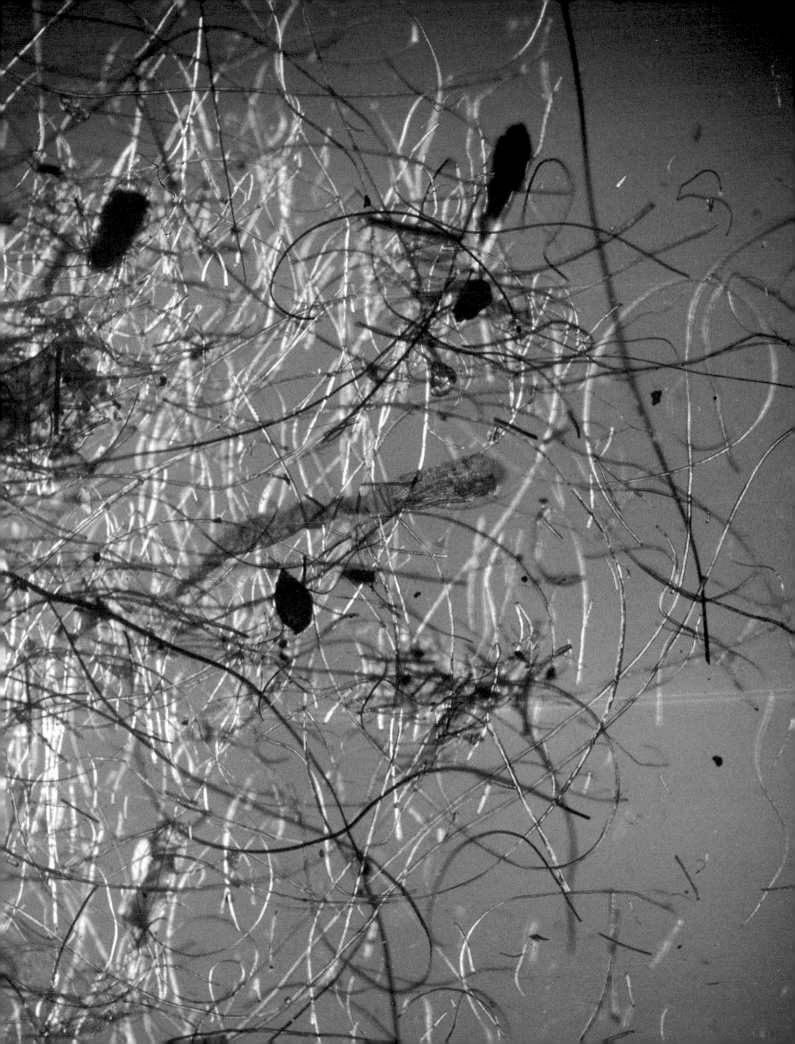

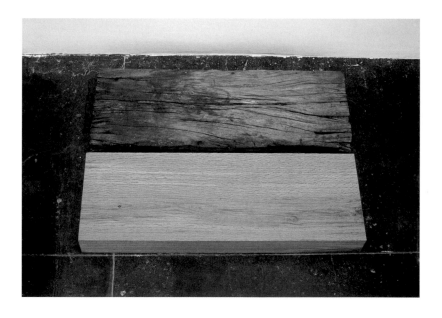

Room for Margins, 1998 Installation detail
Canvas liners from Turner paintings
Courtesy Conservation Department, Tate Gallery

**Ghost Town Threshold, Threshold That Has Never
Been Stepped On**, 1997
Oak

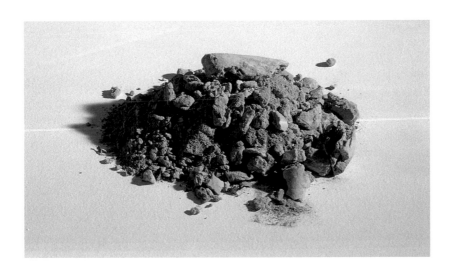

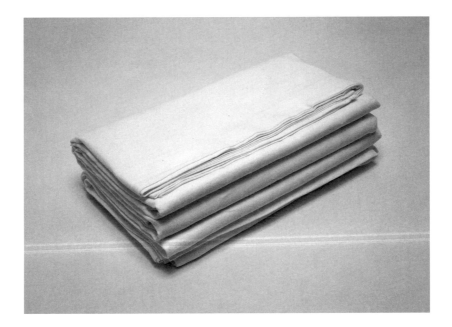

Exhaled Cocaine, 1996
Incinerated cocaine

Inhaled Cliffs, 1996
Sheets starched with chalk from the White Cliffs of Dover

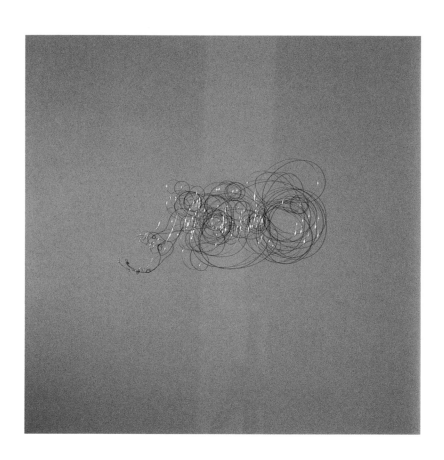

Wedding Ring Drawing, 1996
(Circumference of a living room)
Two 22 carat gold wedding rings drawn into a wire

Cornelia Parker
interviewed by
Bruce Ferguson

OCTOBER 1999

BRUCE FERGUSON: Given the fact that you're recently married, I thought that it would be interesting to talk about *Wedding Ring Drawing*— the gold wedding band which got spun into a thread—as a point of departure because it obviously represents a major theme that you deal with: metamorphosis. Taking a familiar object and then doing something to it.

CORNELIA PARKER: I used the wedding ring because it is an institution, a monumental thing, but at the same time something domestic. In old encyclopedias they use various analogies to describe how ductile gold is, how far you can stretch it as a material. You can in theory make it into a thread that will go around the world, or make it into gold leaf that would cover a room. When I was pursuing these kind of ideas I found a silversmith who could draw precious metals into wire.

BF: How do they actually do that?

CP: What they do is melt the gold into an ingot and then they pull it through a draw plate which is a metal plate with holes in it of varying dimensions getting smaller and smaller. You make an ingot the size of the first hole, and then you physically pull it through the hole until it becomes circular.

If it is a wedding ring that is being made, they draw it through a semicircular shaped hole to form a band. I bought second hand wedding rings and had them melted down and drawn into thread, it was as if the rings were being undone. The length of thread was determined by the capabilities of the silversmith, I just asked how far can you make this piece of gold go?

BF: What was it? 40 feet?

CP: The gold in two rings made approximately 40 feet of wire, that was as far as they could push it with their equipment. If you get into mechanized processes then you can make it much finer. Usually industry that has that kind of equipment is not interested in tiny amounts, they deal in tons.

BF: Were you surprised at the length of it?

CP: I was thinking what kind of dimension is that! Then the idea of the circumference of a living room came to me. I liked its multiplicity of meaning, the idea of trying to measure a domestic or psychological space with an object that could be read as both limited and infinite. The resulting wire is still a kind of loop; the two wedding rings were melted together and drawn into one thread.

When I actually got to start manipulating the material, I was tussling with this springy wire which was getting all tangled up, getting kinks in it and breaking.

BF: Which is another good metaphor. How did you finally display it?

CP: I trapped the coils between two sheets of glass. I've done more than one wedding ring drawing, the idea seemed to lend itself to a series, and there are different states a marriage can get into. There was one drawing that turned out as just a little screwed up bundle of wire that is all confusion, then there's one that is quite lyrical that's not got any breaks in it at all. It's like divining really, reading the tangle of wires like entrails. Hopefully it becomes an object of projection for the viewer.

BF: And of course it's the title that makes it suggestive. If you just see the wire…

CP: It's just a piece of wire, but it has a history. I buy two rings that might have been sold because the owners got divorced. Having them melted down destroys the rings, and then creating a new thread restores them. The piece evolves out of the ambiguity of the material.

BF: How do you feel about the fact that a ring is a symbol, an emblem, that it already is a metaphor? The gold wedding ring symbolizes marriage, union. And then when you take it apart, what do you think it means symbolically?

CP: It does undermine the whole symbolic structure…and as a sculptor, what I'm interested in is the material and how far you can push it. I like the idea of the material already being loaded, or clichéd. By trying to unpick or dismantle something and remake it, somehow the perimeters get changed. What I'm trying to do is take very clichéd

monumental things, things that everybody knows what they are (or you think you know what they are) and then trying to find a flip side to it or the unconscious of it.

BF: When you do that, when you find it's unconscious, then you literally try to unravel its power as it were.

CP: Yes, demystify it. Very often, the reason I may want to play around with these materials is that they're something I fear. For example, I split a coffin and made it into pieces, a variety of sizes of matchsticks and then I took it to a match factory and dipped it into the match material. Each piece of the coffin had its own potential life and death of its own. That's a terrifying thing to do, because you only really touch a coffin if you go to someone's funeral or die yourself. Actually buying one, breaking it into pieces you get to defuse the fear, you get to know the physical stuff it's made of—you realize it's just a piece of wood, like a table, its the shape that makes it symbolic. The same with the gold wedding ring, I'm taking an object that is fixed, immovable and trying to make it into something more about the state of flux.

BF: Do you think that's the same as when you try to find new kinds of places in which to exhibit rather than just galleries?

CP: I think for along time I made work site specifically—in gutters or trees, floating in ponds, where you might accidentally come across it. I'm sure I've made things that no one's ever seen.

BF: Tell me about them.

CP: There is one piece where I drowned souvenir models of famous monuments in my bath water, they blocked up a gutter. I think it's an early avoided object. It only exists as a photograph and

has never been seen by anyone, it's only been in a catalogue, and it's one of my favorite pieces. The fact was that I had filled my house up with junk and the gutter was the next available space left to make work in. I used the house as a studio for a long time so any space is potential space for making work. On the ceilings, underneath the carpet. That's why I did a lot of things suspended from ceilings because that was the only available space. That, and the gutter outside.

BF: I was reading other interviews with you and you were talking at some point about this idea that tiny things could become lethal weapons. It struck me that this was again a kind of metaphor for the notion of the unconscious.

CP: I think everything has the potential to be lethal in a different context. A friend was living in a mobile home in Darwin during the infamous hurricane. He and his wife had to abandon their trailer and run for shelter in a nearby hotel. When they were holed up in the hotel with a lot of other people, they could hear all this thudding on the door, they didn't know if it was others trying to get in—they didn't open the door because the wind was too strong—and the next morning, when they opened the door, it was embedded with splinters and pieces of glass, pieces of straw. These normally benign things, fragile things, would've been lethal, if they had opened the door. That really stuck in my imagination, it was like that story about throwing a sandwich off the Empire State Building and cracking a paving stone—this idea of being killed by a sandwich. These ideas led to those pieces where I shot things through guns that weren't bullets, using things like pearls and money as ammunition.

BF: Is it also about changing scale? In the piece *Aircraft Carrier Shot by a Dime,* obviously the one

thing that happens in that is that the scale of everything changes: the dime becomes the size of a large weapon and the aircraft carrier is a relatively small photograph. So scale is a part of this idea of metamorphosis as well.

CP: In my early works, I would cast lead replicas of architectural souvenirs like the Empire State building which I bought in New York. It was always about being attracted to the most monumental famous clichéd thing and buying the cheapest possible souvenir of it and then mass producing it yourself, you know a badly made bauble, a very crap sculpture. You get this very complex object that can be worn away by mass production, but because it's monumental you only need to read the shorthand of it because you know what it is.

BF: When you speak, you use very traditional sculptor's terms, like negative space as opposed to positive space, about scale, about materials and so on, and yet you're obviously not a traditional sculptor in any way that would normally be understood. I'm interested if those terms came to you later and you realized that you were just using traditional sculptural vocabulary or if that's part of the conscious activity of doing something?

CP: I once heard a critic giving a gallery tour of my work, she was talking about it from a formal point of view, about my choice of making miniature monuments in lead and hanging them upside down being the opposite of the bronze sculpture on a pedestal. That's not a part of my thinking at all. I don't want to make art about art; the motivation for the work is not formal issues like that, but somehow the work is usually subconsciously doing it anyway.

BF: Is it partly because someone like say Carl

Aircraft Carrier Shot by a Dime, 1995
Dictionary shot by a coin, p. 49

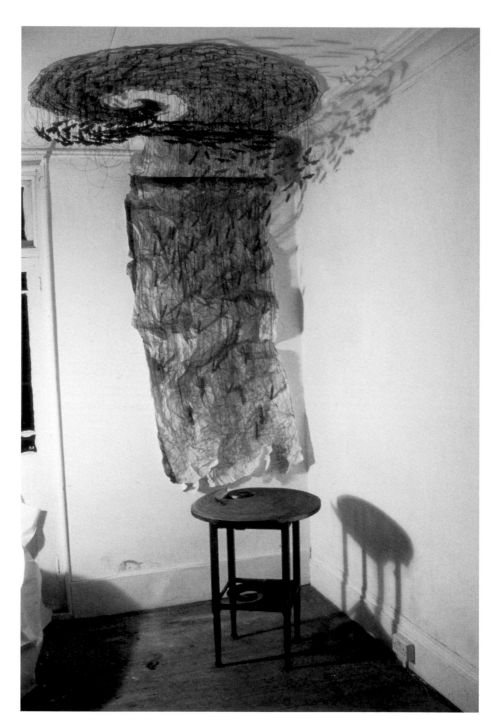

Wave from the Ground, 1985
Cast lead battleships, suspended from a drawing

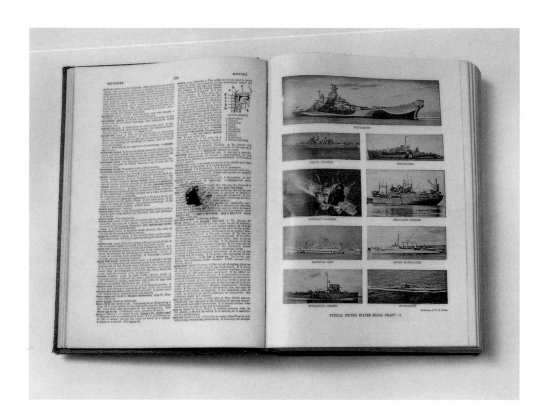

Aircraft Carrier Shot by a Dime, 1995

Dictionary shot by a coin

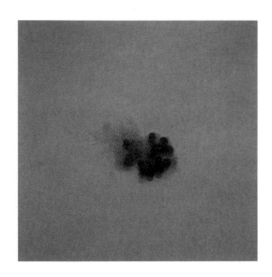

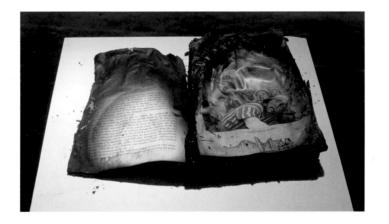

Negatives of Sound, 1996
Black lacquer residue from cutting the original
grooves in records

Temple of Dragon is Destroyed, 1997
Bible retrieved from church struck by lightnimg

Andre has already done the floor pieces that you don't have to think about that? Or is that just not a part of your thinking at all?

CP: I'm aware of all those debates but I think they're not too interesting to me. I always think you can come up with an original thought, and that you don't have to battle with the received idea. It's really like Debono's theory of lateral thinking—you're less likely to dig an original hole if you're an expert who is already at the bottom of a very deep hole. Received knowledge is a deep hole and sometimes it's very hard to climb out of the hole and dig a new one. I don't often read about art, I look at art, but I don't really want to saturate myself with the theory of it. I get my inspiration from reading about science in the newspaper, or perusing objects in a street market. I've learned more about sculptural space or technique in the real world than in sculpture class.

BF: Tell me about *The Negative of Sound*.

CP: It's like the monument again, the idea of all sound produced, and to achieve it what do you have to get rid of? I was trying to imagine what a negative of sound was. I went to a record factory, hoping to find what I was looking for. There they take a nickel silver cast off a lacquer master disc, which is made in a recording studio. So I went to Abbey Road Studios—made famous by the Beatles—to witness that process. Then I realized they engrave away these spaces from the surface with a needle to produce the grooves.

BF: In order to make space for the sound, as it were?

CP: They're engraving the sound, to produce the music they have to excavate the groove, the swirl of lacquer that they have to remove is what I'm interested in. It must be the negative of sound. I wondered what the negative of *Lucy in the Sky with Diamonds* must sound like. For some reason it makes me think of the back of Bernini's sculptures on the roof of St. Peters in Rome. From the ground you see all these perfectly carved apostles but if you go on the roof and look at their backs you can see the roughness of the unfinished stone and the metal supports. Michelangelo's slaves appear the way they do, figures fighting their way out of the stone, because they were intended to be placed against the wall so their backs wouldn't be seen. I love all that.

BF: Your interest is in things that are peripheral or things that have been marginalized. Do you feel marginalized?

CP: I think when I was a child in the country in the middle of nowhere, I was quite a loner. Adolescents always think that they're outsiders. I don't know if that has anything to do with my fascination with this stuff that no one else values. The most popular spot, the most clichéd spot, is where everybody is. So you're wondering why they're there and not over here. I'm really attracted to the popular place too but I'm always trying to find a new space within it. As an artist, I think that's what I really appreciate about other people's work is when you can experience their work and find a space for yourself that's surprising to you. Because there must be space available in the work for you to do that and take something from it A lot of work is sealed off. The ego, or whatever, has taken over and there's no space available. It's about finding space for projection.

BF: And then finding a voice for those objects. If the object speaks a received kind of language, or a received kind of knowledge, then you try to undo it almost like a therapist.

Falling Towers and Sinking Ships, (detail) 1985
Lead casts of a souvenir of
the Empire State Building
p. 53

The Maybe, 1995
Installation at the Serpentine
Gallery, London, pp. 31-33

CP: I suppose it's all about digesting things. If it's one big lump, you can't digest it, so you grind it up or you find a way of making it into a soluble, then you can absorb it. But if it's a lump, like dogma, you find it indigestible, it's hard to absorb.

BF: Isn't that what some of those miniature souvenirs are about? That's a way of absorbing something, taking it home.

CP: I went to New York for two or three months in 1984 and that experience definitely had a huge impact on me. I came back and said, "Oh Gosh, how do I make sense of that?" All I had to show for the experience of it all was a cheap, plastic souvenir of the Empire State building. Somehow by casting hundreds replicas of it in lead and suspending them as plumb lines from the ceiling I was literally trying to fathom something. It was my way of processing an experience, trying to understand something by repeating it over and over again like a mantra until it almost wore away. That process was really a turning point in my work.

BF: You used that one image earlier with the sandwich that falls off the Empire State Building and cracks the pavement, which of course reminds me of this term that you used which is 'cartoons,' or "cartoon deaths." It seems to me there are maybe two things there to talk about. One is that there's something benign—it's not a vicious thing when you metamorphose something, it's benign. Cartoons are the place where reality gets metamorphosed all the time and literally bounces back as it were.

CP: There are a lot of adult cartoons. *South Park, King of the Hill*—they are interesting because there's some kind of social satire going on. Things can be said in cartoons that can't easily be said otherwise—like the wise court jester or fool in

Shakespeare's plays. There's lots of horror in *Grimm's Fairy Tales*, which we find unpalatable nowadays. The cartoon has a lot of horror and violence going on but its comic bloodletting. People always say to me, "You know, your work's really violent," that's only a small part of the work, for some reason they always fixate on the violence. But it's there within everybody; it's very much a part of society. We can't pretend it doesn't exist.

BF: When you say you're trying to create a new space, what kind of space is it? Somebody had said in one of these things that it's a suspended space but I didn't feel it was suspended as much as it was conditional in that you titled that piece with Tilda Swinton, *The Maybe*. It felt more to me like a space that's maybe this and maybe that. Part of it's sort of a holding pattern almost: it might go in a different direction if you wait long enough.

CP: That title came from Tilda. She had an idea to do a performance where she slept as a Snow White character—a fictional character—and she wanted to call it, *The Maybe*. Through our collaboration it changed from her sleeping as Snow White to her sleeping herself. I created an installation around her in the form of a reliquary. "The Maybe," is a really good title. It's all about potential. It's about history; everything is in the past, when somebody dies it's absolute. But up to that second, everything's still completely possible. Up to that second, everything's still in front of you, everything's variable, everything has potential and then the second goes and it's behind you, a building gets finished, someone's born, someone dies. It was about the passage of time, how you can't capture an accurate picture of life, because it's in constant flux. When you think about the history of sculpture and all these monuments, they're fixed, they're made to last. Works of art last far

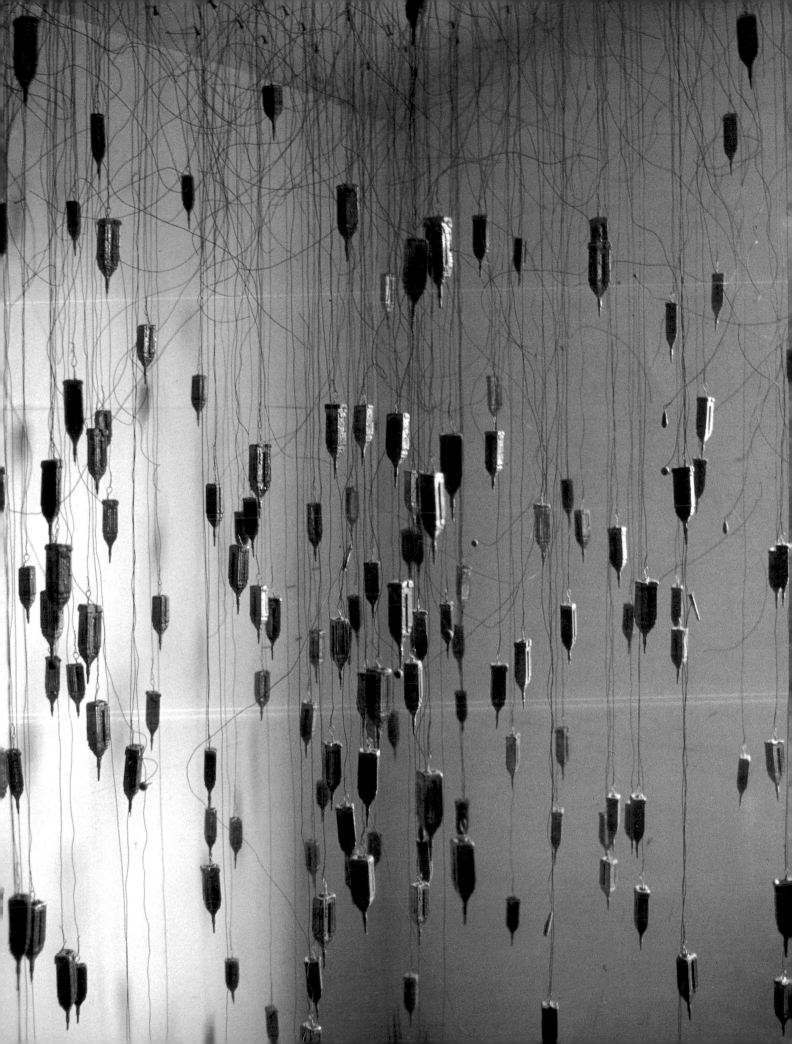

longer than the artist, they get reinterpreted over and over by various generations of people. It's trying to make, with the work, a representation of how you feel about the ephemerality of life.

BF: You call it a reliquary, the pieces in *The Maybe* that surrounded Tilda Swinton—the piece of Lindbergh's aircraft and so on. One of the things that's intriguing of course is that there's no way for us as an audience to know the truth of the object we're looking at.

CP: That's why the word reliquary is a quite good one because being brought up as a Catholic, the idea of the relic is the splinter from the cross.

BF: Which of course depends entirely on faith.

CP: I think that faith has got a lot to do with art. As far as I know, those objects I chose to display were what the museums I borrowed them from said they were.

BF: But how would I know? How would I know you're not putting me on?

CP: I think it's up to the audience, the viewer is perfectly entitled to be a cynic if they want to be. It depends if you're a half-glass empty or half-glass full kind of person. I want the work to reflect what the viewer is as a person. So if you're a cynic, you'll think they're all fake and you'll spend the time thinking about that. If you're quite happy to accept them at face value, then you're off on another planet somewhere else. What's interesting about the show is Tilda's presence there. Some people didn't think it was Tilda, but an impostor. Some people thought she was a waxwork. It says much about that viewer, and about their own sense of mortality in the end. Some of the relics I chose because they belonged to household names that have become part of our language, Freudian,

Victorian, Dickensian....There were varying degrees of fame represented, a home made printing press I exhibited belonged to a folk hero known as the Protein Man. He would only be known by people who lived in London, he walked up and down Oxford Street protesting against eating protein because he thought it promoted lust.

BF: One of those Hyde Park figures?

CP: A classic character who was there protesting for about 20 years till he died. Anybody who ever walked down Oxford Street would know whom you were talking about. Someone who comes from Japan who's looking at the exhibition wouldn't know who the Protein Man was but might be intrigued. Someone like Dickens who for all his huge tomes that he contributed to literature was represented by a little scruffy feather with which he wrote his last novel. Lindbergh was represented by a scrap of canvas from his plane.

BF: You're acting like an artist, but you're also acting like a curator. A museum curator does that all the time: they determine which objects are of historical value or carry the historical narrative.

CP: I've tried to not use the word curator in terms of that show. I wanted you to view the objects as sculptural material with which you could build an exquisite corpse, arranging them to strike up new narratives. Faraday's spark apparatus placed beside Babbages's brain hinting at a Frankenstein monster. Charles Dickens's pen, Virginia Woolf's check, Kitchener's glove—all exhibited in close proximity. Imagine the gloved hand with the pen signing a check.

BF: Do you want to talk about the school building you covered with chalk? That strikes me as the same sort of thing, where you're emptying something out in order to refill it.

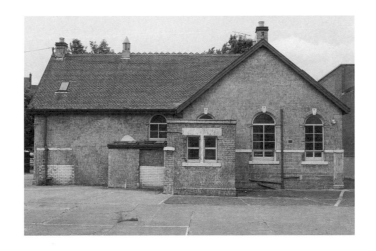

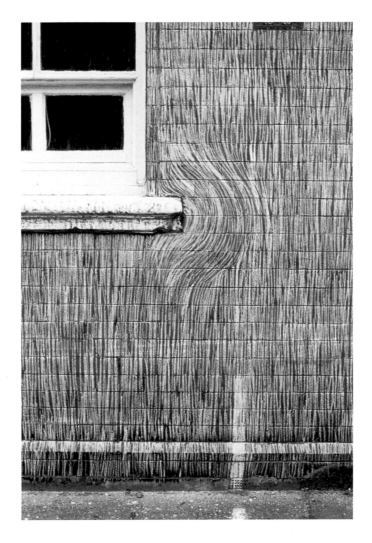

Exhaled Schoolhouse,
1990
schoolhouse in Glasgow,
exterior entirely covered in
tiny chalk marks

Exhaled Schoolhouse,
(detail) 1990

Cornelia Parker cutting up objects for **Shared Fate**, 1998, using the guillotine that cut off Marie Antoinette's head. Madame Tussauds, London

CP: There was an empty school building in Glasgow that was recently vacated. I went to look at the building and all I could see there was these boxes of chalk. I thought that I really wanted to do a giant chalk drawing. You never touch a building all over, but looking at the building, the idea of touching the whole exterior surface was a compelling idea. We spent this whole week on scaffolding around the building covering its entirety with small chalk marks. The school was Victorian and I'm sure there were hundreds of lessons where chalk was used, countless of strokes must've been made inside the schoolhouse over the years.

BF: Millions, I would think.

CP: It was almost like an accumulation of all this chalk exhaled through the walls, marking time. It was ephemeral because it washes away. It was almost like a way of dematerializing the school building, another institution.

BF: Like churches and marriage. Obviously with *Cold Dark Matter: The Exploded View*, you actually blew up a building which was probably scarier for everybody but you. What was the motivation for that?

CP: I had done the piece with the steamroller— *Thirty Pieces of Silver*—and the piece with the train running over coins—*Matter and What it Means*. I was thinking of different ways of killing something off. I think the explosion was another clichéd cartoon death. At the time I was living in a house that was due to be knocked down for a motorway in a few months time, but it kept getting postponed for another six months and so on for almost ten years. I think because of living for such a long time with this constant threat of demolition that is where the steamroller and explosion

ideas came from. But it wasn't a home I blew up; it was just a garden shed, a surrogate. It's another British institution, the garden shed.

BF: It feels more like J. J. Ballard than T.S. Eliot somehow, doesn't it? It has more of that kind of wit.

CP: I think it came from all kinds of places. It's a modern condition: the threat of bomb scares, and the fear it symbolizes. From seeing explosions on the news and all the time in films you sort of think you know what they are, but really your firsthand knowledge of it is very limited. I realized I'd never walked through the detritus of a bombed-out building.

BF: It's almost like you believe things are animated. Or that they're potentially animated. That they're sitting there still but if you do something to them then they're going to be animated.

CP: I like the life/death resurrection bit, which is very Catholic, something dies, but it's resurrected in another form. A few months ago I made a piece using the guillotine that chopped off Marie Antoinette's head its called *Shared Fate*. It's just a few objects that I chopped up using the guillotine. It's in Madame Tussaud's Chamber of Horrors. It's a real relic from the revolution, yet it's surrounded by all these gory waxworks, which everybody's fascinated with. They just pass by this guillotine which for me is the most chilling thing there. Madame Tussaud was there at the French Revolution. She sculpted a lot of them when they were rich nobility, kings, queens. Then later when they had their heads chopped off, she did the death masks of their decapitated heads. She was a pretty canny woman; she bought the guillotine as a souvenir, before she moved to England.

BF: What did you bring to chop up?

Cold Dark Matter: An Exploded View, 1991
Garden shed, blown up for the artist by the British Army, the fragments suspended around the lightbulb from the shed. p. 25

Thirty Pieces of Silver, 1988-89
Steamrollered silver plate, metal wire, p. 10

Matter and What it Means, 1989
Coins that have been run over by a train, suspended over a shadow of dirty money, p. 14

CP: It was very hard to think what to cut up. I chopped everyday things, a loaf of bread, a newspaper, a tie…very banal objects. Actually, I only exhibited the ones I managed to cut up, 200 years of corrosion and the blade is not very sharp anymore. The instrument of revolution is blunt. I just wanted to test its metal, I suppose, to see how sharp it was. Actually running my finger on the edge of it, was the most horrendous, chilling experience I've ever had. Very often the sculpture is just a flimsy excuse for me to get my hands on these things that change the face of history.

BF: The head of history, I think.

CP: One of the things I held in my hands in Connecticut was a little wooden barrel that Nathaniel Colt carved when he was sixteen—of the revolver.

BF: The Colt revolver?

CP: It was just a tiny bit of wood that changed history. I was just holding this thing in my hands. Something benign becomes quite powerful…It goes both ways. In the piece *Embryo Firearms* the two lumps of metal I present are pre-empted guns. The sculpture isn't pro-gun or anti-gun; it occupies a kind of limbo space. I don't want to make issue based work. I'm trying not to have too much of the artist's hand in there. The work really makes itself; you are just rearranging materials. The charcoal church piece—I had lots of religious people write to me. For some reason they think I'm deeply religious.

BF: Your sense wasn't that you were resurrecting the church, really?

CP: I was reconstituting it. It's now abstract. You can't really tell it's a church unless you read the label. There was a crucifix shaped piece of wood

that I had retrieved but I didn't include it in the piece as it seemed too obvious.

BF: I would love to hear you talk about your relationship to language. My sense is that you distrust language the same way you distrust these objects.

CP: I love writing, I love literature, I suppose that and art were the two things I enjoyed most at school. I think I'm probably a frustrated writer.

BF: Frustrated writer, frustrated curator….

CP: I sometimes frustrate curators! Whether we like it or not, images and words are an integral part of our world, especially in England, we are a very literary society. I think in a way the label, the title, liberates me quite a lot. It allows the material to be transformed beyond recognition without having to give up its history, like in *Wedding Ring Drawing*.

BF: It almost seems like you've got fact and fiction, or two kinds of versions of the same reality. One is language, which may or may not be telling the truth, and the other is the material, which may or may not be telling the truth. They sort of play off one another.

CP: There's a lot of information there and you can do what you will with it. I had the misfortune to switch on the TV during the Turner Prize, watching the critics discussing my work, dissecting it, arguing about the labels.

BF: I think the work does in a way go beyond language, it almost defies language, but then it has to return to language because that's how we think. Or the ways we think are eventually described in language.

CP: The work's a physical model of a thought process, speaking one language, and the title is

Embryo Firearms, 1995
Colt .45 guns in the earliest stage of production, p. 23

writing another. I always thought drawing was a bit like writing.

BF: Talk to me about *Grooves in Hitler's Record*. That's like the *Negative of Sound* but it's a little differently charged.

CP: It was an extension of using famous people's relics in *The Maybe*. I thought about what it would be like to look at some of these things through a microscope, what stories were there that you couldn't see. One of the objects I had borrowed was a record that belonged to Hitler. It wasn't included in the show because of the potential media distortion, they would've taken it out of context. So I took it forward into the next body of work, the *Avoided Object* series. The view from the microscope seemed to be one of scrutinizing a dark history or a secret, a piece of Tchaikovsky, knowing Hitler had listened to it. It stirred up all kinds of emotions, then you remembered that Hitler was an aesthete but a failed artist.

BF: In a way, it's like Theodore Adorno's point when he said you can't make poetry after Auschwitz. The fact that art didn't redeem anything. Here's a guy that's listening to the greatest art in the world and simultaneously killing seven million people. It's not like there's a rational relationship between the two.

CP: I've recently done something similar with Einstein's equations on a blackboard in the Museum of the History of Science in Oxford. He gave three lectures there. There's one blackboard left preserved that he worked on. Looking through the microscope at the chalk marks he made and making images of those, you can see the pressure of his hand…the chalk broke at one point, you get this truncated little mark. They're very gestural, very loose, whereas the equations are very neat

when you look at them a long way off. I struggle to understand Einstein, Freud, Hitler…but somehow by looking at something really closely that they're associated with—like the creases in Freud's chair, you can sort of make a different more intuitive sense out of them. I think I know more about the theory of relativity by looking through a microscope at his equations; looking is a different kind of knowledge.

BF: It seems that the knowledge you're after, that the knowledge you create, is like a forensic knowledge. That is to say, it's like a detective's knowledge.

CP: I don't think I make conclusions like forensic science. They're trying to be quite precise in the end. I don't understand the equations. I'm trying to find a gleam of other information and I'm not quite sure what that is. I was once invited to contribute to a conference entitled "What Do You Think You're Doing: Intention In Making Art," I always find it hard to talk about intention because I think intention is just a decoy. Its just a strategy to get you on a journey from A to B but what you find on the journey is something else. I use ideas but an idea is not necessarily what its all about, the idea is just a kind of skin.

BF: If you look at an artist's work, you can see that certain artists use certain kinds of structural variations. One thing you do is you stretch everything. Even when you're just hanging something that is an ordinary thing, you hang it so that it stretches the space or it stretches from one place to another. Is it just a proclivity you have? Or do you think of it as stretching the truth, stretching time, and there's a way in which it acts metaphorically.

CP: It's pushing something as far as it will go, seeing where the limitations, the boundaries are, trying to defy gravity. I suppose that's what the sus-

Einstein's Abstracts, 1999 Photomicrographs of the blackboard covered with Einstein's equations from his lecture on the theory of relativity, Oxford, 1931, p. 60

Einstein's Abstracts, 1999
Photomicrographs of the blackboard covered with
Einstein's equations from his lecture on the theory of
relativity, Oxford, 1931

pending is about. I'd like to do a project where I return a meteorite back to space, to zero gravity. It's like reversing gravity. Gravity is what happens to you over a lifetime, the earth's grip on all of us.

BF: When you speak of gravity, you use this term, "dead center." You don't just say it's at the center of the earth, it's at the dead center of the earth. I remember reading something that you said where it's the dead center that for you it is also tied to some notion of life and death?

CP: Gravity and death are very bound up together, the lines in your face, the effort of putting one foot in front of the other. When you're young you're skipping about, and then later as you age your feet start to drag.

BF: The reason I was thinking about stretching… Americans use the term, I don't know if the British use the same term, but when somebody proposes an idea that is almost beyond credibility but is almost within the parameters Americans say "well, it's quite a stretch."

CP: I know what you mean but I think it's more of an American term. I know it through watching American TV. I think it's also a cartoon thing, stretching, also a sculptural one. You're literally forging, stretching metal, then there is metal drawing. It's literally a technical term, I like technical terms.

BF: Especially when they have so much resonance.

CP: I think when you stretch something you get more for your money. What can you make out of nothing?

BF: You obviously don't think systematically. And yet at the same time, there are threads that run through pretty much all of the work about notions of the familiar and the unfamiliar; metamorphosis, marginality, peripherally…

CP: I'm always surprised about how consistently thematic my work is because I feel I almost start from scratch every time. It's not like I think well what comes next, logically? I leap around a lot. In the end, it's all coming from the same source so I guess it'll always add up. Especially with the small work, the avoided objects, works from different periods can be exhibited side by side quite happily. I can rearrange them for an exhibition and make new meanings, seeing what works together, they have different lives by the way they're placed by other things. That's exciting because it's like making a new piece of work.

BF: They start to get new lives, new friends, new relations. I think I saw some of your small *Avoided Objects* in New York at the Apex Gallery.

CP: A pillow that had been cut by a king's sword with a gold-tooth crown, a poet's crown sitting on it. They were exhibited alongside photograms of feathers taken from the pillow on Freud's couch. I like those things together because you assume that the feathers in the photograph are the ones spilling out of the pillow, and they aren't. When I showed them the first time, I borrowed this feeding bowl from the London Zoo, which had been chewed up by a lion. It's got these huge tooth marks all over it made by the king of the jungle. Exhibited next to the pillow, it looked like some poor creature had met his death.

Meteorite Lands in Tivoli Gardens, 1996
Display using fireworks containing fragments of
an iron meteorite

Meteorite Lands in Epping Forest, 1996
Firework made with iron from a meteorite

Hanging Fire (Suspected Arson), 1999
Charcoal, wire, pins, nails
Installation at the Frith Street Gallery, London

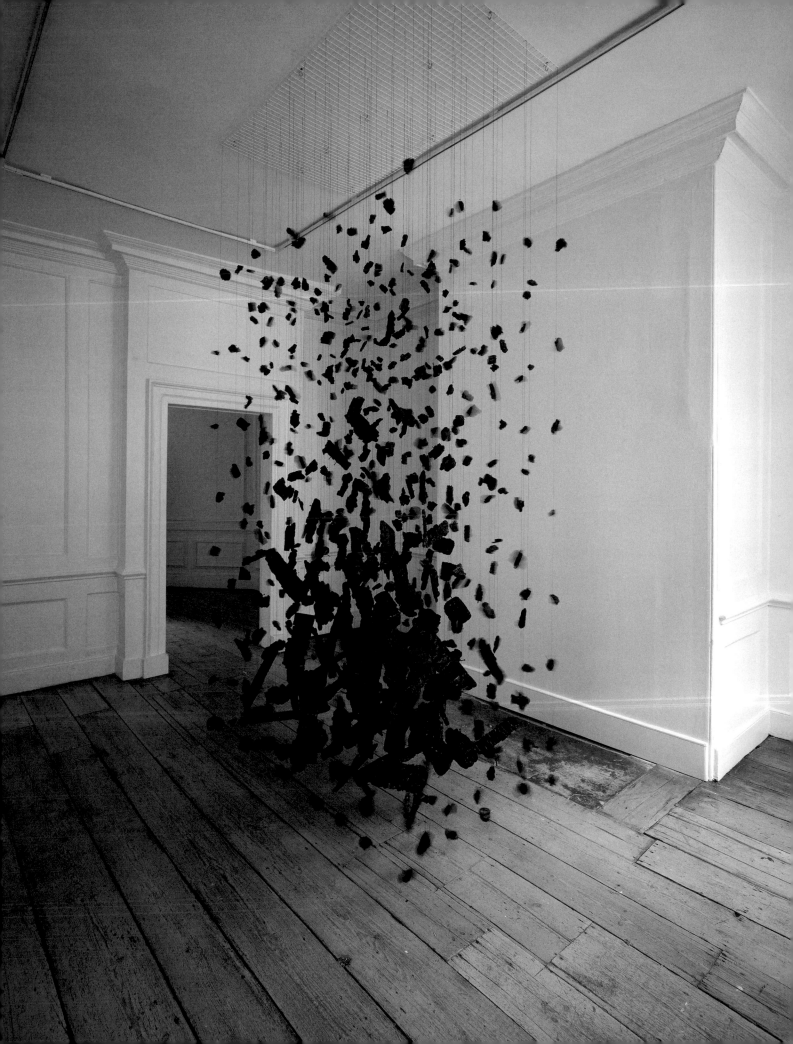

Checklist

Aircraft Carrier Shot by a Dime, 1995
Dictionary shot by a coin
11 x 8.4 x 2.4 inches (28 x 21 x 6 cm)
Courtesy of the Artist and Frith Street Gallery, London

Aside of England, 1999
Chalk retrieved from a cliff fall at Beachy Head,
South coast, England
Chalk, wire, and mesh
5 x 5 feet (152.5 x 152.5 cm)
Courtesy of Private Collection, London

Avoided Object, 1995
Buried object discovered Dusseldorf, Germany
with the aid of a metal detector
0.6 x 3 x 3 inches (1.5 x 7.5 x 7.5 cm)
Collection of the Artist, London

Avoided Object, 1999
Set of four photographs of the sky above the
Imperial War Museum
Taken with the camera that belonged to Hoess,
commandant of Auschwitz.
Camera kindly lent by the Imperial War Museum.
24.4 x 24.4 inches (62 x 62 cm)
Courtesy of the Artist and Frith Street Gallery, London

Breath of a Librarian, 1998
Burst balloon discovered in the reading room of
the British Library
Diameter 3 inches (8cm)
Courtesy of the Artist and Frith Street Gallery, London

Collected Death of Images, 1996
Reclaimed silver from photographic fix
24 x 24 inches (61 x 61 cm)
Courtesy of the Artist and Frith Street Gallery, London

*Dress, Shot with Small Change (Contents of a
Pocket)* 1995
Ladies velvet dress
Dimensions variable
With special thanks to Colt Firearms
Courtesy of Dimitris Daskalopoulos, Athens, Greece

Suit, Shot by a Pearl Necklace, 1995
Man's suit
Dimensions variable
With special thanks to Colt Firearms
Courtesy of Dimitris Daskalopoulos, Athens, Greece

Einstein's Abstracts, 1999
Photomicrographs of the blackboard covered
with Einstein's equations from his lecture on the
theory of relativity, Oxford, 1931
Cibachromes on aluminum
23 x 29.7 inches (58.5 x 75.5 cm)
With thanks to the Museum of the History of Science, Oxford
Courtesy of the Artist and Frith Street Gallery, London

Embryo Firearms, 1995
Colt. 45 guns in the earliest stage of production
Each 7.5 x 5 x 0.95 inches (19 x 13 x 2.4 cm)
With thanks to Colt Firearms Manufacturing, CT, USA
Courtesy of the Artist and Frith Street Gallery, London

Embryo Money, 1996
Ten pence pieces in the earliest stage of protution
2.75 x 10.6 x 6.7 inches (7 x 27 x 17 cm)
With thanks to the Royal Mint
Courtesy of the Artist and Frith Street Gallery, London

Embryo Record, 1996
7 inch single, vinyl
0.9 x 2.2 x 2.9 inches (2.5 x 5.5 x 7.5 cm)
Courtesy of the Artist and Frith Street Gallery, London

Engagement Ring Drawing, 1996
Scratches made with a diamond on glass
Courtesy of the Artist and Frith Street Gallery, London

Exhaled Cocaine, 1996
Incinerated cocaine
Dimensions variable
With thanks to HM Customs and Excise
Courtesy of the Artist and Frith Street Gallery, London

Explosion Drawings, 1999
3 drawings made with charcoal, sulfur and saltpeter
Each: 24.8 x 24.8 inches (63 x 63 cm)
Courtesy of Private Collection, New York

Feather from a Wandering Albatross, 1998
Photogram
24 x 24 inches framed (61 x 61 cm framed)
With thanks to the British Antarctic Survey, Cambridge
Courtesy of the Artist and Frith Street Gallery, London

Feather from Benjamin Franklin's Attic, 1998
Photogram
24 x 24 inches framed (61 x 61 cm framed)
With thanks to the Benjamin Franklin Museum, London
Courtesy of the Artist and Frith Street Gallery, London

Feather from Freud's Pillow, 1998
(From his couch)
Photogram
24 x 24 inches framed (61 x 61 cm framed)
With thanks to the Freud Museum, London
Courtesy of the Artist and Frith Street Gallery, London

Feather that went to the South Pole, 1998
(In the sleeping bag of Sir Ranulph Fiennes on his trip across Antarctica)
Photogram
24 x 24 inches framed (61 x 61 cm framed)
With thanks to the Royal Geographic Society
Courtesy of the Artist and Frith Street Gallery, London

Feather that went to the Top of Everest, 1997
(in the jacket of Rebecca Stephens, the first British woman to climb Everest)
Photogram
24 x 24 inches framed (61 x 61 cm framed)
Courtesy of the Artist and Frith Street Gallery, London

Raven Feather from the Tower of London, 1998
Photogram
24 x 24 inches framed (61 x 61 cm framed)
Courtesy of the Artist and Frith Street Gallery, London

Ghost Town Threshold, Threshold That Has Never Been Stepped On, 1997
Oak
3 x 28 x 10 in. (7 x 66 x 24 cm)
Courtesy of the Artist and Frith Street Gallery, London

Giraffe Lick, 1998
Salt block
7.9 x 7.9 x 6 inches (20 x 20 x 15 cm)
With thanks to London Zoo
Courtesy of Private Collection, New York

Hanging Fire (Suspected Arson), 1999
Charcoal, pins, nails
Courtesy of the Artist and Frith Street Gallery, London

Inhaled Cliffs, 1996
Sheets starched with chalk from the White Cliffs of Dover
16 x 10 x 4.3 inches folded (41 x 25.5 x 11 cm)
Courtesy of the Artist and Frith Street Gallery, London

Mammoth Hair Drawing, 1996
Mammoth hair discovered in a Siberian glacier
24 x 24 inches framed (61 x 61 cm framed)
Courtesy of the Artist and Frith Street Gallery, London

Measuring Liberty with a Dollar, 1998
Silver dollar drawn into a wire the height of the Statue of Liberty
24 x 24 inches framed (61 x 61 cm framed)
Courtesy of Eileen and Peter Norton, Santa Monica

Measuring Niagara with a Teaspoon, 1997
Georgian silver spoon drawn to the height of Niagara Falls
24 x 24 inches (61 x 61 cm)
Courtesy of Rebecca and Alexander Stewart, Seattle

Meteorite Lands in Epping Forest, 1996
Firework made with iron from a meteorite
Backlit transparency
23.8 x 17.5 inches (60.5 x 44.5 cm)
Courtesy of the Artist and Frith Street Gallery, London

My Soul Afire, 1997
Hymnal retrieved from a church struck by
lightning in Lytle, Texas, USA
1.4 x 14 x 8.7 inches (3.5 x 36 x 22 cm)
Courtesy of the Artist and Frith Street Gallery, London

Negatives of Sound, 1996
Black lacquer residue from cutting the original
grooves in records
24 x 24 inches (61 x 61 cm)
With thanks to Abbey Road Recording Studio, London
Courtesy of the Artist and Frith Street Gallery, London

Negative of Words, 1996
Silver residue accumulated from engraving words
4.1 x 4.1 x 3 inches (10.5 x 10.5 x 7.8 cm)
Courtesy of the Artist and Frith Street Gallery, London

Object that Fell Off the White Cliffs of Dover, 1992
Silver teapot
6 x 6.7 x 4 inches (15 x 17 x 10 cm)
Courtesy of the Artist and Frith Street Gallery, London

One Day This Glass Will Break 1995
Six etched glasses
17 x 3 inches (43 x 7.5 cm)
Courtesy of the Artist and Frith Street Gallery, London

Pillow Cut by King's Sword, 1998
Cotton, feathers
4.7 x 26.4 x 15 inches (12 x 67 x 38 cm)
With thanks to The Royal Armouries, Tower of London
Courtesy of the Artist and Frith Street Gallery, London

Poet's Crown, 1998
Dental gold
0.4 x 0.4 x 0.4 inches (1 x 1 x 1 cm)
Courtesy of the Artist and Frith Street Gallery, London

Poison and Antidote Drawings, 1997
2 drawings
Rattlesnake venom and ink, anti venom and
correction fluid
24 x 24 inches each (61 x 61 cm)
Courtesy of the Artist and Frith Street Gallery, London

Pornographic Drawings, 1997
Ink made from dissolving videotape (confiscated
by HM Customs & Excise) in solvent
3 drawings, each 24 x 24 inches (61 x 61 cm)

With thanks to HM Customs and Excise
Courtesy of the Artist and Frith Street Gallery, London

Projections, 1996–1999
Mark Twain Spider
Freud Feather
Slide projections
Dimensions variable
Courtesy of the Artist and Frith Street Gallery, London

Room for Margins, 1998
Margins and canvas liners from paintings by
J. M. W. Turner
Installation
Courtesy of Tate Gallery, London

Sculptures Made by Elephants, 1998
Wood
29 1/2 x 8 1/2 and 29 1/2 x 11 1/2 (75 x 21.5 and 75 x 29 cm)
With thanks to London Zoo
Courtesy of the Artist and Frith Street Gallery, London

Shared Fate, 1998
Objects cut by the guillotine that beheaded
Marie Antoinette
Mixed media
Dimensions variable
With thanks to Madame Tussauds, London
Courtesy of the Artist and Frith Street Gallery, London

Spent Light Bulb Exposed by a Match, 1999
Photogram
27.5 x 23.8 inches (70 x 60.5 cm)
Courtesy of Richard Lappin, New York

Spent Match Exposed by a Live One, 1999
Photogram
24.8 x 24.8 inches (63 x 63 cm)
Courtesy of The Henry Moore Foundation, Leeds

Stolen Thunder 1997-1999 (12)
Tarnish from Samuel Colt's Soup Tureen, 1997
(inventor of the Colt. 45 gun)
Oxidized silver on cotton handkerchief
24 x 24 inches framed (61 x 61 cm framed)
With thanks to the Wadsworth Atheneum, Connecticut
Courtesy the Artist and Frith Street Gallery

Tarnish from James Bowie's Soup Spoon, 1997
(inventor of the Bowie knife)
Oxidized silver on cotton handkerchief
24 x 24 inches framed (61 x 61 cm framed)
With thanks to the Daughters of the Republic of Texas, The Alamo
Courtesy the Artist and Frith Street Gallery

Tarnish from Davey Crockett's Fork, 1997
Oxidized silver on cotton handkerchief
24 x 24 inches framed (61 x 61 cm framed)
With thanks to the Daughters of the Republic of Texas, The Alamo
Courtesy the Artist and Frith Street Gallery

Tarnish from Horatio Nelson's Candlestick, 1998
Oxidized silver on cotton handkerchief
24 x 24 inches framed (61 x 61 cm framed)
With thanks to Lloyd's of London
Courtesy the Artist and Frith Street Gallery

Tarnish from Charles Dickens' Knife, 1998
Oxidized silver on cotton handkerchief
24 x 24 inches framed (61 x 61 cm framed)
With thanks to the Charles Dickens House Museum, London
Courtesy the Artist and Frith Street Gallery

Tarnish from a Spoon Bent by a Psychic, 1999
Oxidized silver on cotton handkerchief
24 x 24 inches framed (61 x 61 cm framed)
With thanks to the Society for Psychical Research, London
Courtesy the Artist and Frith Street Gallery

Tarnish from Charles Darwin's Sextant, 1998
Oxidized brass on cotton handkerchief
24 x 24 inches framed (61 x 61 cm framed)
With thanks to the Royal Geographic Society
Courtesy the Artist and Frith Street Gallery

Tarnish from a Football Trophy (Hammers), 1998
(UEFA Cup Winners Cup, 1965)
Oxidized silver on cotton handkerchief
24 x 24 inches framed (61 x 61 cm framed)
With thanks to West Ham United Football Club
Courtesy the Artist and Frith Street Gallery

Tarnish from Charles I's Spurs, 1998
Oxidized silver on cotton handkerchief
24 x 24 inches framed (61 x 61 cm framed)
With thanks to The Royal Armouries, Tower of London
Courtesy of the Artist and Frith Street Gallery, London

Tarnish from the Inside of Henry The Eighth's Armour, 1998
Oxidized silver on cotton handkerchief
24 x 24 inches framed (61 x 61 cm framed)
With thanks to the Ashmolean Museum, Oxford
Courtesy the Artist and Frith Street Gallery

Tarnish from a Communion Cup, 1998
Oxidized silver on cotton handkerchief
24 x 24 inches framed (61 x 61 cm framed)
With thanks to St. Clement Dane's Church, London
Courtesy the Artist and Frith Street Gallery

Tarnish from Guy Fawke's Lantern, 1998
Oxidized steel on cotton handkerchief
24 x 24 inches framed (61 x 61 cm framed)
With thanks to the Ashmolean Museum, Oxford
Courtesy of the Artist and Frith Street Gallery

Thirty Pieces of Silver, 1988-89
Steamrollered silver plate, metal wire
Dimensions variable
Courtesy of Tate Gallery, London

Three Fathoms in a Thimble, 1997
Silver thimble drawn into wire and threaded through a needle
24 x 24 inches (61 x 61 cm)
Courtesy of Private Collection, Boston

Twenty Years of Tarnish (Wedding Presents) 1996
Two silver plated goblets
Each 5.1 x 2.6 x 2.6 inches (13 x 6.5 x 6.5 cm)
Courtesy of Rebecca and Alexander Stewart, Seattle

Wedding Ring Drawing, 1996
(Circumference of a living room)
Two 22 carat gold wedding rings drawn into a wire
24 x 24 inches (61 x 61 cm)
Courtesy of Rebecca and Alexander Stewart, Seattle

Another Matter (detail, one of 20 windows), 1993
Installation in the Grassimuseum, Leipzig
Wine, water, glass

Cornelia Parker

BIOGRAPHY AND BIBLIOGRAPHY

1956 Born Cheshire, England
1978 B.A. Hons. Wolverhampton Polytechnic
1980-82 M.F.A. Reading University
 Lives and works in London

SELECTED ONE PERSON EXHIBITIONS

1999 Frith Street Gallery, London
 Warburg Institute, London
 Science Museum, London
1998 Serpentine Gallery, London
 Deitch Projects, New York
1997 ArtPace, San Antonio, Texas
1996 *Avoided Object*, Chapter Arts Centre, Cardiff
1995 *The Maybe* (Collaboration with Tilda Swinton), Serpentine Gallery, London
 Gallery 102, Dusseldorf
1992 Eigen & Art, Leipzig
 Vitrine Hortense Stael, Paris
 Lost Volume: A Catalogue of Disasters, Victoria & Albert Museum, London
1991 Chisenhale Gallery, London
 Vitrine Hortense Stael, Paris
 Spitalfields Heritage Centre. Presented by the Whitechapel Gallery, London
1990 Edge 90, *Inhaled Roof,* Newcastle
 Edge 90, *Exhaled Schoolhouse,* Glasgow
1989 Cornerhouse, Manchester
 Aspects Gallery, Portsmouth
 Edge 90, *Left Luggage,* Platform 6 St Pancras St, London
1988 Ikon Gallery, Birmingham
 Installation for St. Peters Church, Kettle's Yard, Cambridge
1987 Actualities, London
1980 Stoke City Art Gallery & Museum, Stoke-on-Trent

2000 *Interventions*, Milwaukee Art Museum, Wisconsin

1999 *Documents and Lies*, Optica, Center for Contemporary Art, Montreal

 Melbourne 1st International Biennial, Melbourne, Australia

 Postmark: An Abstract Effect, SITE Santa Fe, Santa Fe, New Mexico

 Violent Incident, Tate Gallery, Liverpool

 Powder, Aspen Museum of Art, Aspen, Colorado

 Appliance of Science, Frith Street Gallery, London

 Avoiding Objects, Apex Art, New York

1998-99 *Silver and Syrup: Selections from the History of Photography,* Canon Photography Gallery, Victoria & Albert Museum, London

 Fun de Siecle: Irony Parody and Humour in Contemporary Art, Walsall City Art Gallery, Walsall, West Midlands

 Contemporary British Artists, Denver Art Museum, Denver, Colorado

 Thinking Aloud, Kettle's Yard, Cambridge; Cornerhouse, Manchester; Camden Arts Centre, London

1998 *Yoko Ono's Water Piece,* Ormeau Bath Gallery, Belfast

 Sarajevo 2000, Museum Moderner Kunst Stiftung Ludwig, Vienna

 New Art from Britain, Kunstraum Innsbruck, Austria

 Video / Projection / Film, Frith Street Gallery, London

 Destroyer / Creator, John Webber Gallery, New York

1998 *Drawing Itself*, The London Institute, London

 Soon, Het Consortium, Amsterdam

 Drawing Show, Glasgow Print Studio, Glasgow

 The MAG Collection, The Fruitmarket Gallery, Edinburgh

 Natural Science, Stills Gallery, Edinburgh

1997 *The Turner Prize*, Tate Gallery, London

 Material Culture, Hayward Gallery, London

 Nightshift, Schloss Pluschow, Germany

 Building Site, Architectural Association, London

 Critical Intervention, Jose Loff Gallery, Hartford Art School, Hartford, Connecticut

1996 *Matter of Facts,* Hawerkamp, Münster

 City Space, Tivoli Gardens, Copenhagen

 Some Drawings from London, 20 Princelet St, London

 Good News, Galerie 102, Düsseldorf

1995 *Something The Matter: Helen Chadwick, Cathy de Monchaux, Cornelia Parker,* Museo Municipal de Bellas Artes, Rosario, Argentina; Centro Cultural Recoleta, Buenos Aires; Museo National de Bellas Artes, Rio De Janeiro; Galeria Athos, Bulcao, Brazil

A House in Time, Moderna Galerija Ljubljana, Slovinia

Eigen & Art, London

The Edge of Town, Jose Loff Gallery, Hartford, Connecticut

Five Artists, Frith Street Gallery, London

1994-5 *Art Unlimited,* South Bank, London

1994 *XXII Bienal de São Paulo,* Brazil

1993-5 *Recent British Sculpture,* British Arts Council Touring Exhibition

1993 Eigen & Art, New York

Ha-Ha, Killerton Park, Devon

Topos, Grassimuseum Leipzig, Austria

1992-3 *Sweet Home,* Oriel Moystn, Llandudno, Wales; South London Art Gallery

1992 Nigel Greenwood, London

Eigen & Art, Berlin

Whitechapel Open, London

Northern Adventures, Camden Arts Centre; St Pancras Station, London

Through the Viewfinder, Stitching De Appel, Amsterdam

1991 *Excavating the Present,* Kettle's Yard, Cambridge

Tous Azimuts, Vitrine Hortense Stael, Paris

1990 *The British Art Show,* Mclellan Galleries, Glasgow; Leeds City Art Gallery, Leeds; Hayward Gallery, London

Mostra, British School, Rome

Rome Scholars 1980–90, Royal College of Art, London

Edge 90, Newcastle, Glasgow

Whitechapel Open, Whitechapel Gallery, London

River, Goldsmiths Gallery, London

1987 *Systems of Support,* Kettle's Yard, Cambridge

1986 *Surveying the Scene,* South Hill Park, Bracknell; Aspects Gallery, Ports

National Garden Festival, Stoke-on-Trent

New British Sculpture, Air Gallery, London

No Place Like Home, Cornerhouse, Manchester

1980 *Midland View,* Stoke City Art Gallery & Museum, Stoke-on-Trent

1998-99 Artist in Residence, Science Museum, London

1998 *Best Show by an Emerging Artist,* International Association of Art Critics Prize, New York

1997 International Artist in Residence, ArtPace Foundation for Contemporary Art, San Antonio, Texas

Koopman Chair, Jose Loff Gallery, Hartford Art School, Hartford, Connecticut

Brushes With Fame, Seven Little Frictions, Audio Arts, London

Avoided Object, 5 Artists' Inserts, *NATURE,* International Weekly Journal of Science – Vol. 389, Issues 6648-6652

1996 City Space, Commission for European City of Culture, Copenhagen

1995 Tate Gallery Christmas Tree, Tate Gallery, London

1992-5 Senior Fellow in Fine Art, Cardiff Institute, Wales

1992 Installation at Union Station, Los Angeles. Organized by Wise/Taylor

1991-92 Henry Moore Scholarship, Wimbledon School of Art

1989 British School at Rome Award

1988 Sculpture Residency and Commission, Forest of Dean, Gloucestershire

1986 Siteworks Project, Southwark, London

1985 Artist-in-School Project, Rugby, West Midlands

Greater London Arts Award

1984 Artist-in-School Project, Walsall, West Midlands

1983 Southern Arts Award

1980 First Prize *Midland View,* Stoke City Art Gallery

1979-80 Artist-in-Residence, Crewe & Alsager College, Cheshire

Kent, Sarah, *Cornelia Parker – Frith Street*, **Time Out**, October 20-27, 1999, p. 52

Jones, Jonathon, *Cornelia Parker*, **The Guardian**, Wednesday 22 September, 1999, p. 19

Green, Charles, *Signs of Life, 1st Melbourne International Biennial*, **Artforum**, September 1999, p. 178

Buck, Louisa, *UK Artist Q & A – Cornelia Parker*, **The Art Newspaper-Dealers Gazette**, N0.95, September 1999, p.178

Burton, Jane, *Exploding onto the Scene*, **Artnews**, February 1999, pp.104-106.

Frankel, David, *Cornelia Parker – Deitch Projects,* **Artforum International**, September 1998, p. 152

Hensher, Philip, *How Deep is a Hole,* **Modern Painters**, Summer 1998, p. 42

Koplos, Janet, *Cornelia Parker at Deitch Projects,* **Art in America**, June 1998, p. 102

Currah, Mark, *Video, Projection, Film,* **Time Out**, June 10-17 1998, p. 47

Kent, Sarah, *Here's the Thing,* **Time Out**, May 20-27 1998, Art Preview, p. 54

Searle, Adrian, *What the Butler Saw*, **The Guardian**, May 19, 1998, G2 Section, pp. 8-9

Feaver, William, *Jumble Fever,* **The Observer**, May 17, 1998

Field, Marcus, *The Story of Art,* **Blueprint**, May 1998, pp. 40-42

Moggach, Lottie, *Cutting Edged,* **Times Metro**, May 16-22 1998, pp. 24-25

Kent, Sarah, *Object Lessons,* **Time Out**, May 13-20 1998, pp. 14-15

Büchler, Pavel, *Avoided Objects,* **Creative Camera**, February/March 1998, pp. 36-37

Mahoney, Elisabeth; *Natural Science – Stills Gallery,* **Art Monthly**, Issue 214, March 1998, pp. 33-34

Mahoney, Elizabeth; *An Ounce of Gold around the Globe,* **Make**, Issue 79, March–May 1998, pp. 22-23

Cotter, Holland, *Cornelia Parker* (at Deitch Projects), **The New York Times**, April 3, 1998

Levin, *Cornelia Parker* (at Deitch Projects), **Voice Choices**, April 7, 1998

Kemp, Martin, *Parker's Pieces,* **Nature**, Vol. 392 – 16 April 1998, p. 663

Button, Virginia, *Interview with Cornelia Parker*, **NINETY**, No.27 May 1998 Issue pp. 41-71

Pearman, Hugh, *One Good Turner Defeats Another,* **Sunday Times**, 7 December 1997, pp. 6-7 (Culture Section) and *Turner Artist Makes a Meteoric Career move into Outer Space,* p. 3 (News Section)

McEwen, John, *Catholic Smithereens,* **The Daily Telegraph**, 30 November 1997, p. 12

Coomer, Martin, *Rogues' Gallery,* **Time Out**, 26 November-3 December 1997 'Art – Turner Prize' and p.10 *Place your Bets,* 'Hotshots' section

McEwen, John, *It has to be Parker,* **The Sunday Telegraph**, 2 November 1997, Art Section

Gale, David, *Art, that's a Blast,* **Telegraph Magazine**, 25 October 1997, p. 53

Allen, Lucy, *The Turner Prize 1997: Nominees,* **Tate Magazine**, Issue 13 / Winter 1997

Cornelia Parker in Conversation with Susan Butler, **Untitled – A review of Contemporary Art** Winter 1996/97 pp. 8-9

Lores, Maite, *Cornelia Parker: Avoided Object,* **Contemporary Visual Arts**, Issue 14, Summer 1997, pp. 72-73

Cornelia Parker, **Illustrative London News**, June 1996

Buck, Louisa, *Boxing Tilda,* **Artforum**, January 1996 p. 27

Davies, Tristan, *Cornelia Parker,* **The Daily Telegraph**, Christmas 1995, "A Week in the Arts" Section

Cornelia Parker and Tilda Swinton, **Art Monthly**, October 1995, p. 25

Gale, Iain, *Suspending Objects in Disbelief, ArtNews*, September 1994, pp. 150-151

Smolek, Naomi, *Cornelia Parker: Eigen + Art, Artforum*, November 1992

Martin, Andre, Lessard, Denis, *Documents & Songes*, catalogue published to accompany exhibition *Documents and Lies*, Optica, Center for Contemporary Art, Montreal, 1999, 32 pp. ISBN2-922085-04-X.

Robinson, Deborah and Shaul, Matthew, Guide published by The Walsall Museum and Art Gallery to accompany the exhibition *Fun de Siecle: Irony Parody and Humour in Contemporary Art* at Walsall City Art Gallery from 17th December 1998 to 14th February 1999, ISBN 0946652503.

Corrin, Lisa G, *Cornelia Parker,* Guide published by the Serpentine Gallery, London to accompany one person exhibition from 11 May to 14 June, 1998, 12 pp, color and B&W illustrations.

Wilson, Gerard and Hart, Janice, *Drawing Itself,* published by Sunbather Ltd., London, 1998, to coincide with an exhibition of artists' drawings at the London Institute Gallery from 19 March to 30 April 1998, 38 pp., color illustrations, ISBN 1902462009.

Bann, Stephen and Hopkins, David, *Natural Science*, guide produced to coincide with the group show at Stills Gallery between 28 January and 21 March 1998, 10 pp.

Buck, Louisa, *Moving Targets: A User's Guide to British Art Now*, published by the Tate Gallery Publishing Ltd., London, 1997, 192 pp., ISBN 1854372238.

Button, Virginia, *The Turner Prize* 1997, guide published by Tate Gallery Publishing, London, 1997, 14 pp., color illustrations, ISBN 1854372211.

Glinkowski, Paul, *Date with an Artist,* catalogue published to accompany the BBC television series of the same name aired Autumn 1997 and the exhibition *Date with an Artist* at the Northern Gallery for Contemporary Art, Sunderland from 21 November 1997 to 14 February, 1998, color illustrations, 46 pp., ISBN 100171005X.

Archer, Michael and Hilty, Greg, *Material Culture*, catalogue published to accompany a group exhibition at the Hayward Gallery, London from 3 April to 18 May 1997, 32 pp., ISBN 1853321656.

Brett, Guy; Parker, Cornelia; Cameron, Stuart and Payne, Antonia; *Cornelia Parker – Avoided Object;* published in an edition of 1,500 to accompany the exhibition at Chapter Arts Centre from 5 October to 24 November 1996, Cardiff, 1996, color and B&W illustrations, 80 pp., reprinted 1998, ISBN 1900029030.

Bingham, Juliet; Masterson, Piers and Maynard, Sarah, *You are Here: re-siting installation*, catalogue to accompany the exhibition curated by The Royal College of Art of MA students, including *From Presence to Absence: round table discussion between Cornelia Parker, Richard Wentworth and Richard Wilson*, color and black and white illustrations, 1997, 96 pp., ISBN 18715616.

Hello: Artists in Conversation, publication published by the Royal College of Art, London, includes 'Neither from nor Towards: Cornelia Parker talks with Alexandra Bradley', 1996, 128 pp. ISBN 1874175160.

Buck, Louisa, *Something the Matter*, catalogue published by the British Council for the XXII

Bienal de São Paolo, Helen Chadwick, Cathy de Monchaux and Cornelia Parker, 1994, 48 pp., color illustrations, ISBN 0863552633.

Archer, Michael; De Oliveira, Nicolas; Petry, Michael and Nicola, Oxley; *Installation Art*, published by Thames Hudson, Ltd., London, 1994, 208 pp., color illustrations, ISBN 0500236720.

Watkins, Jonathan, *Cornelia Parker – In Suspense,* catalogue published to accompany a group show at Ausstellungshaus im Grassimuseum Leipzig from 6 May to 27 June 1993, pp. 30-33.

Eigen + Art (Ed.), *Cornelia Parker – Neither From Nor Towards,* 1991, 28 pp.

Parker, Cornelia and Searle, Adrian, *Cornelia Parker – Cold Dark Matter: An Exploded View,* catalogue published to accompany the exhibition at Chisenhale Gallery from 18 September to 27 October 1991, 9 pp.

Spent Match Exposed by a Live One, 1999
Photogram